IMAGES
of America

GRAND ISLAND
AND HALL COUNTY

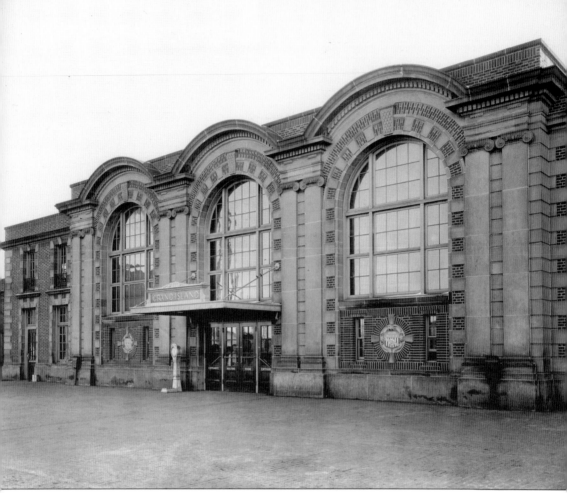

The front entrance to Grand Island's Union Pacific Railroad passenger depot (above) was once a stately edifice of brick with stone trim that featured high-arched windows. The structure was designed by the architectural firm of Carrere and Hastings of New York City and was considered one of the finest small-city depots on the Union Pacific system. Grand Island's third Union Pacific passenger depot opened in May 1918, near the intersection of North Locust and West South Front Streets. The depot was razed in 1967 to make way for today's United States Post Office.

On the cover: An unidentified worker ties off a sack of White Elephant Flour in Henry Glade's Grand Island Roller Mill in about 1910. The mill was located on West South Front Street between Wheeler and Walnut Streets. German-born Henry Glade came to Grand Island in 1884. The Glade family business evolved into Nebraska Consolidated Mills in 1920, eventually becoming today's ConAgra, Inc. (Courtesy of the Lumbard-Leschinsky Studio Collection: Stuhr Museum of the Prairie Pioneer.)

IMAGES
of America

GRAND ISLAND
AND HALL COUNTY

Thank you,
Stuhr Museum

Stuhr Museum of the Prairie Pioneer

ARCADIA
PUBLISHING

Published by Arcadia Publishing
Charleston SC, Chicago IL, Portsmouth NH, San Francisco CA

Printed in the United States of America

Library of Congress Catalog Card Number: 2006933895

For all general information contact Arcadia Publishing at:
Telephone 843-853-2070
Fax 843-853-0044
E-mail sales@arcadiapublishing.com
For customer service and orders:
Toll-Free 1-888-313-2665

Visit us on the Internet at www.arcadiapublishing.com

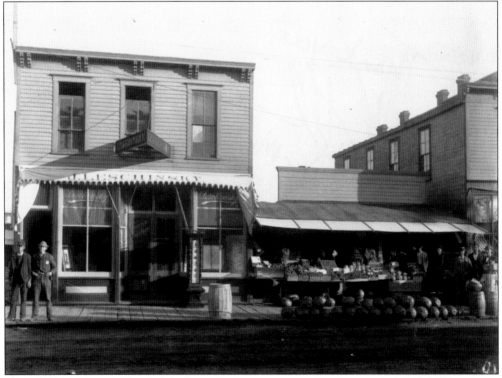

On the left is the second of three studios operated by Grand Island photographer Julius
Leschinsky. He took over this two-story frame building at 113 East Third Street from another
early Grand Island photographer, Michael Murphy, in 1891. In about 1894, the studio moved
into a two-story brick building at 109 East Third Street. Also pictured is W. H. Quillin's fruit
stand, the one-story frame building at right.

CONTENTS

ACKNOWLEDGMENTS

In 1960, the citizens of Hall County, Nebraska, voted to support the creation of Stuhr Museum of the Prairie Pioneer. Since that time, the museum has been preserving and portraying the inspiring era of pioneer town builders who created the first communities in Nebraska. We would be unable to do so without the loyalty and support of our community.

Every day Stuhr Museum fulfills the vision of our founder Leo B. Stuhr, a descendant of early Hall County settlers who understood the value of history. Under the leadership of board members, such as long-time president S. N. "Bud" Wolbach, Stuhr Museum has grown into one of the top 10 living history museums in America and received accreditation from the American Association of Museums.

The photographs in this book were taken from Stuhr Museum's collection of nearly 60,000 photographs. Over the years, thousands of donors have entrusted their family treasures to the museum. Without the generosity of our donors, Stuhr Museum could not exist.

One photograph collection in particular deserves special mention. In 1980, the museum received the Lumbard-Leschinsky Studio Collection. The collection is the legacy of Grand Island photographer Julius Leschinsky and is composed of over 28,000 original glass plate negatives, approximately 4,000 photographic prints, and hundreds of pieces of early-20th-century photographic studio equipment. Through the lens of his camera, Leschinsky has allowed us a rare look at how the citizens of our community lived, worked, and played. Stuhr Museum is working toward the preservation of this unique and priceless collection.

I would also like to recognize the members of the Museum Operating Board, who encourage us to find new ways to share history. Whether raising money, making lemonade for the Victorian Teas, or playing proofreader for this book, your support and willingness to pitch in is noticed and appreciated.

Special thanks needs to be given to Josh Casey. Josh spent the summer of 2006 as an intern in the research department selecting photographs, writing captions, and keeping this book on track. Thank you, Josh, for all your hard work.

Karen Keehr
Curator, Research Department
Stuhr Museum of the Prairie Pioneer

INTRODUCTION

As the story of Hall County is retold through the compelling images in this book, you will be transported to the past and to the common themes that impacted everyday life on the plains. During this journey, you will be introduced to the diverse communities where Hall County citizens lived their lives. The rise, fall, successes, and failures of these communities are captured forever in these images. You will get to know Grand Island, Wood River, Doniphan, Cairo, and Alda, and remember Abbott, Runelsburg, Schauppsville, and Cameron.

In the 1700s, few knew the area that became Hall County, Nebraska. The most prominent feature of the area was a large island surrounded by the north and south channels of the Platte River, which stretched over 50 miles in length. French traders named it Le Grand Ile. The island was very important to the Pawnee Indians, an indigenous Nebraska tribe, who used it as a source of timber for their lodges and as a safe refuge for their horses. As western migration began, the island was an important feature looked for by those who traveled along the many trails that passed throughout the area, including the Mormon, to Oregon and California.

In 1857, a small group of settlers, mostly German and a few American, arrived in the area of the central plains that would one day become Hall County, Nebraska. Arriving before the government surveyors, they were effectively squatters. These dedicated pioneers were charged with establishing a settlement along the Platte River by Chubb Brothers and Barrows of Davenport, Iowa; Washington, D.C.; and Boston, Massachusetts, along what was hoped to be the path of the planned transcontinental railroad. They arrived on July 2, 1857, in the area where the Wood River joined the Platte River, just across from the large island. Relocating two days later to an area a few miles to the east, they laid out their settlement. As with most settlements, they faced trials and setbacks, but over time, more settlers came and built the foundation that our communities stand on today.

Hall County was organized in 1858 and the influential railroad arrived the following decade in 1866. The settlers had chosen a location along one of the most important human migratory paths in North America. The people of Hall County would see decades of trail traffic, gold rushers, railroads, and later highways, along this important path.

As settlers found their way west, many communities were established in Hall County. Some grew and prospered, others faded with time, but all the people associated with them helped to build the communities we have today.

As these communities grew, remembering the past became an important concern. The Hall County Historical Society was founded in 1922, and charged with the care of various artifacts of the past. In the 1950s, the need was seen for a facility to store the artifacts already collected and

the artifacts that were promised to come. With strong community support, and especially the support and vision of Leo Stuhr, the Stuhr Museum of the Prairie Pioneer was born. The Stuhr Building opened in 1967, just 110 years after the first settlers arrived in the area.

Over time, the Stuhr Museum has been the beneficiary of many generous gifts—family treasures that people were willing to share with the museum for the future. Included in these gifts is the Julius Leschinsky Collection of photographs. With this collection, the Edgar and Francis Reynolds Research Library and Archives at Stuhr Museum is home to over 60,000 images, the bulk of which are from the Leschinsky Collection. It is from this outstanding collection that the images used in this book were chosen.

Narrowing down the photographs from 60,000 to the ones before you was a challenge because they each make a personal connection. The images immortalize the daily lives of the residents of Hall County, Nebraska, from 1870 to 1929. Grand Island and Hall County were places of diversity in their citizens and their stories. These stories, frozen in time by the lens of a camera, are truly the heart and soul of America.

These glimpses into the past show you the evolution of Hall County from its humble beginnings to a thriving center of commerce. This commerce took a wide variety of forms, such as the world's second largest livestock yard that shipped thousands of horses and mules all over the world during World War I. Small home and cottage industries, like Dora Kolbeck's dressmaking school, also contributed to the richness of the area. The lasting impact of the railroads that crossed the nation was not one sided in Hall County. The railroad brought in raw materials, such as fruits and vegetables, for businesses like the Brown Wholesale Fruit Company to distribute. They also allowed local businesses like the Glade Mill and Doniphan Brickworks to reach consumers nationally with their products.

Yet, Hall County was not all work and no play. Hall County enjoyed varied social and cultural opportunities. The Liederkranz and the Platt-Duetsche Verein allowed German immigrants to maintain a slice of home here in Nebraska. Other organizations like the Melody Men, Grand Army of the Republic, and St. Cecilia Society pulled together like-minded individuals to serve their needs and enrich the community. Local baseball teams battled for bragging rights, citizens enjoyed picnics at the Sand Krog Resort and concerts at the Bartenbach Opera House. These activities were all part of a wide variety of recreations available to the people of Hall County.

The strength of a community often lies in its timeless institutions. From the one-room sod rural schools to the halls of academia found at the Grand Island Baptist College, Hall County residents have long been committed to education. Enjoy a walk through the golden rule days as the images in this book guide you from kindergarten through the carefree days of college. The churches of Hall County have been, and still are, important icons of the community. Hall County families worshipped at both simple country churches and imposing structures like St. Stephen's Episcopal Church.

Home is where the heart is. The heart of Hall County can be seen in the houses and living spaces of its citizens. Peek in on the Leschinsky family's Christmas, see the Paine children play with their toys, and appreciate the rustic simplicity of Heinrich Egge's log cabin to grasp the importance of home in their lives.

You truly get to see a moment in someone's life through these images. Some of these moments will surprise you, some will make you laugh, and some will ring familiar within your own memories. Just as these images can capture only a brief moment in time, these few images are but a fraction of the story of the people of Hall County.

If you would like to learn more about the history of Hall County or plan a visit to Stuhr Museum of the Prairie Pioneer, visit us at www.stuhrmuseum.org.

One

COMMUNITY

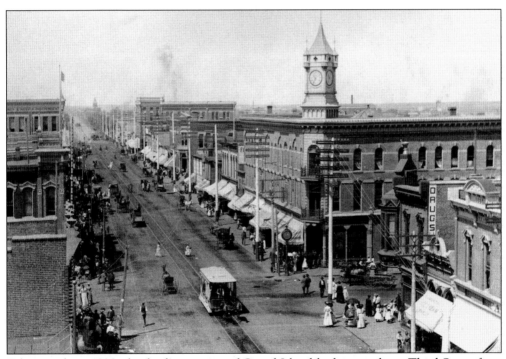

Taken in about 1890, this bird's-eye view of Grand Island looks west down Third Street from its intersection with Pine Street. A mule-drawn trolley car of the Grand Island Street Railway Company is eastbound at the intersection. An ornate clock tower rises from the Michelson Building, on the northwest corner of Third and Pine Streets. The Michelson Building, constructed in the 1880s, still stands today, minus the clock tower. There is considerable pedestrian traffic, especially in front of Wolbach's Department Store, on the southwest corner of Third and Pine Streets. Several horse-drawn vehicles can be seen as well. This photograph was taken from atop the Bank of Commerce, located in the Scarff Building on the southwest corner of Third and Sycamore Streets.

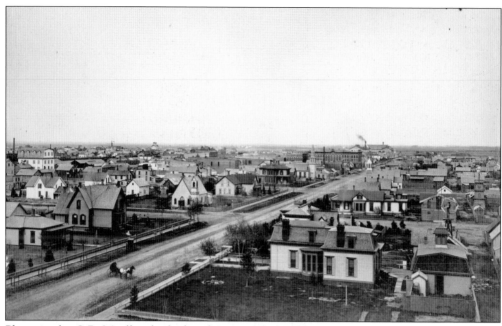

Photographer J. R. Moeller climbed to the top of the Hall County Courthouse in 1885 and 1890 to take a series of photographs that documented the growth of Grand Island. Looking east down Third Street, these images clearly illustrate the building boom Grand Island experienced in the late 1880s. The top image was taken in 1885 and the lower image in 1890. Visible at the far left in both images is the Glade Mill, a flour mill built in 1884 by Henry Glade. St. Stephen's Episcopal Church (center), located at the northeast corner of Second and Cedar Streets, transforms from a small frame church dedicated in 1871 to the stone church built in 1889. It still stands today.

Completed in June 1873, Hall County's original courthouse was believed to have been the third brick courthouse in Nebraska. This photograph was taken before the clock tower was removed in the mid-1880s. After the 1904 opening of today's courthouse at First and Locust Streets in Grand Island, this courthouse was abandoned and eventually razed. The Women's Park Association played a key role in developing the old courthouse square into today's Pioneer Park.

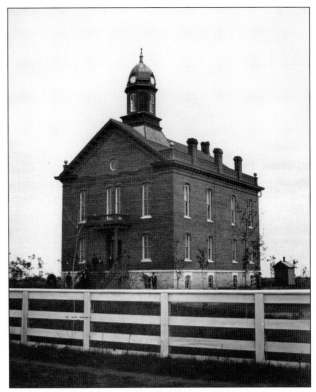

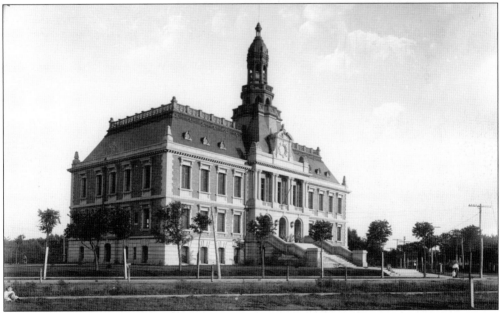

Thomas Rogers Kimball, an Omaha architect, designed the second Hall County Courthouse, seen here shortly after its completion in 1904. It was built by local Grand Island contractors Henry Falldorf and Otto Kirschke. The total cost of the project, which included the Hall County Jail, was $131,141.51. Located at the corner of First and Locust Streets, the courthouse is still in use today.

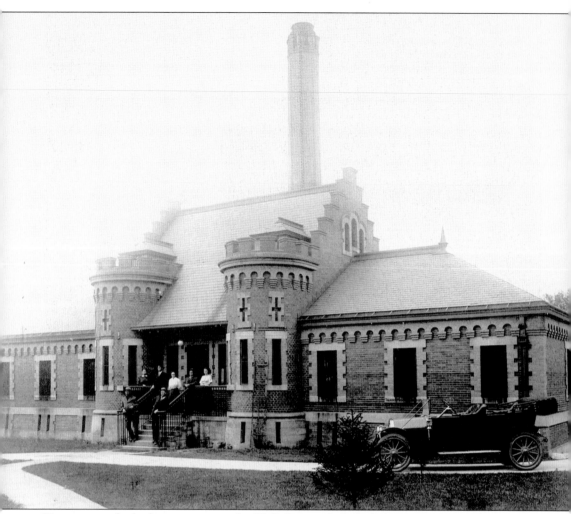

Twin turrets flank the entrance to the Hall County Jail. Built between 1902 and 1904, the jail was included in the construction project of the Hall County Courthouse. The jail cost $11,418 of the project's total of $131,141.51. It was located to the south of the courthouse near the intersection of Pine and Court Streets. The brick chimney rising from the jail was associated with the early steam heating plant for both the jail and the courthouse. Four men and three women pose on the jail's front steps. Hall County sheriff James M. Dunkel is the man on the top step, second from the right between the two women. Dunkel was sheriff from 1906 to 1912.

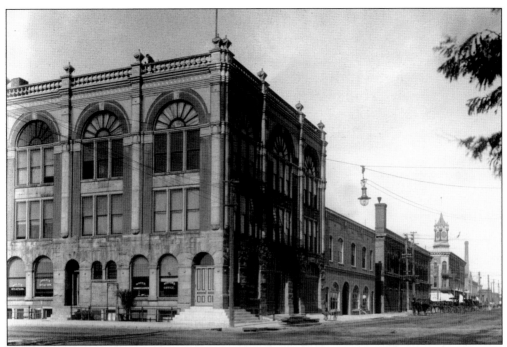

Located at the northwest corner of Second and Pine Streets, the Grand Island City Hall was completed in 1890. The building housed the city's central fire station (northeast corner), the Grand Island Police Department (southwest corner), and the office for the city's Water Commission. The building was razed in 1938 to make way for construction of a new city hall, which was completed in 1940 and still stands today.

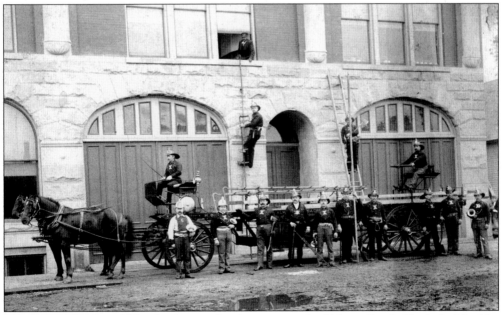

Members of the Grand Island volunteer fire department, the "Always Ready Hook And Ladder Company," pose outside their headquarters in the old city hall in their parade uniforms. The horse-drawn ladder truck seen in this late 1890s photograph was purchased for $1,800 in 1887.

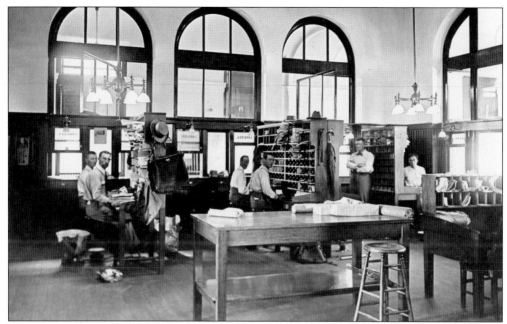

Several workers can be seen sorting mail inside Grand Island's post office. Still standing at the southwest corner of Second and Locust Streets, the post office building opened in 1910. This photograph was likely taken shortly after its completion and before the 1935 addition. Now known as the Federal Building, it was added to the National Register of Historic Places in February 2006.

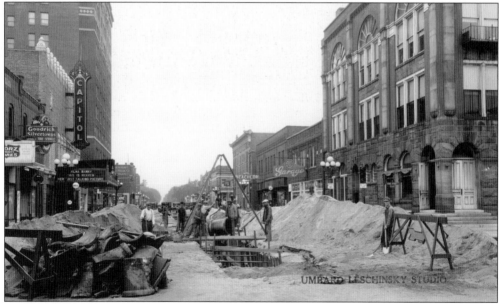

A crew of unidentified city workers repairs a sewer line in the 100 block of West Second Street in approximately 1929. The three-story building at the northwest corner of Second and Pine Streets is the Grand Island City Hall. Other businesses visible include Hartsough Motors, Hotel Beachlor, Capitol Theater, Yancey Hotel, City Water Light and Ice Department, Bartenbach Opera House, Dodd's Tire Service, Rose Brothers, and Abbott Music Company.

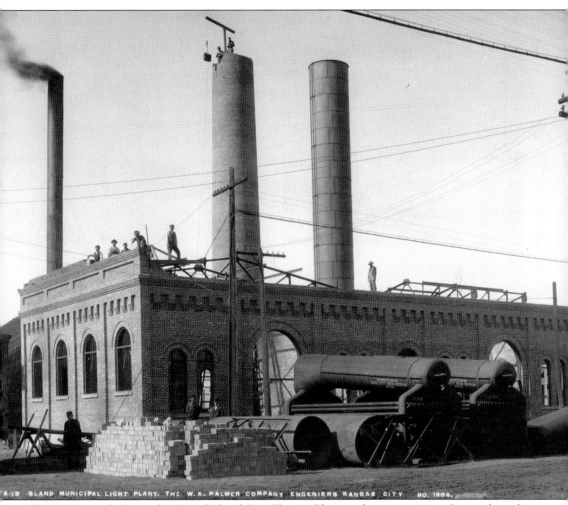

A-D SLAND MUNICIPAL LIGHT PLANT. THE W. K. PALMER COMPANY ENGENIERS KANSAS CITY MO. 1906.

This photograph shows the Grand Island City Electric Plant under construction. Located north of the Union Pacific Railroad tracks on North Front Street, the brick structure and its 132-foot high smokestack were completed in April 1906. During its dedication on November 9, 1906, Grand Island mayor Henry Schuff climbed one of the smokestacks and christened the Grand Island Municipal Light Plant saying, "By the virtue of the office of Mayor of Grand Island I christen you 'success.'"

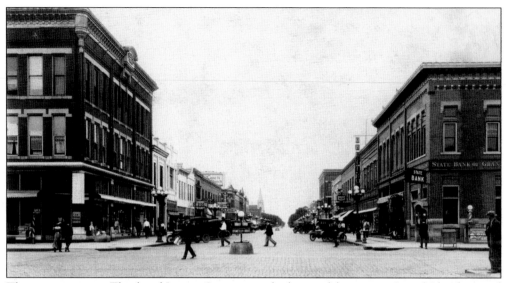

The intersection at Third and Locust Streets was the heart of downtown Grand Island around 1915. The building at left is the Hedde Building. At this time, the ground floor of the three-story brick structure was occupied by A. W. Sterne's menswear store. The State Bank of Grand Island occupied the building at right. This two-story brick structure, originally known as the Koenig Building, was remodeled in 1914 for the State Bank.

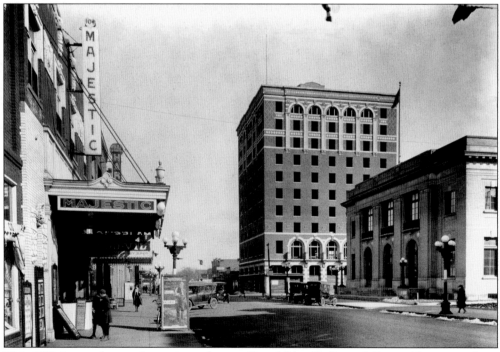

This 1922 image shows a lazy winter day on Grand Island's Second Street. Two young boys examine movie posters outside the Majestic Theater. A few cars are parked in front of the Grand Island Post Office. The Yancey Hotel stands partially completed at the southeast corner of Second and Locust Streets. Construction of the Yancey Hotel began in April 1917. Financial problems delayed completion of the hotel until 1923.

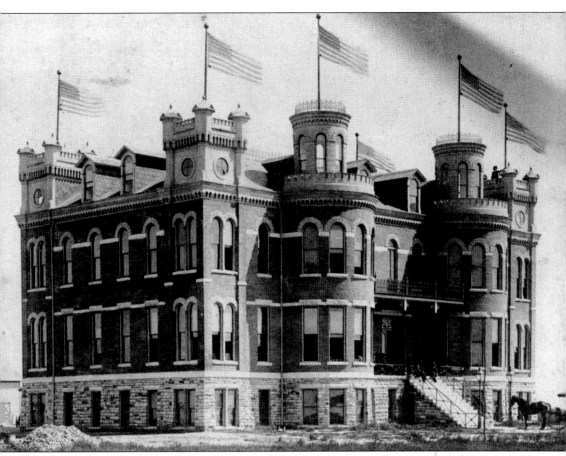

Nebraska state legislation approved the location of the state veteran's home on March 4, 1884, in Grand Island, stipulating that no fewer than 640 acres be donated for the site. The Grand Island Board of Trade raised $25,600 for land purchased in April 1887, three miles north of the city. Seen here, the Soldiers' and Sailors' Home's main building, the Lincoln Building, was dedicated on June 26, 1888. The brick and stone building was designed by Grand Island architect Julius Fuehrmann. This photograph was taken before the 1896 addition to the Lincoln Building. It was razed in 1930 to make way for a new Nebraska Veterans' Home administration building, completed in 1931.

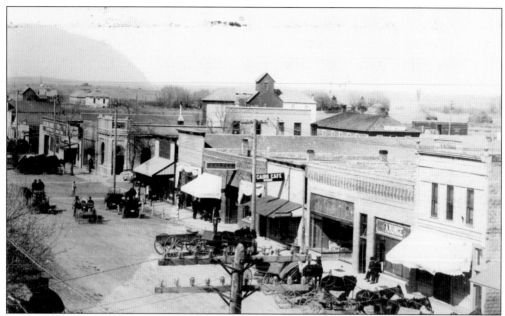

Taken in about 1916, this photograph of Cairo looks at the east side of the 300 block of South High Street. The buildings are, from left to right, Smith's livery stable (partially visible), Nelson Lumber and Supply Company, unidentified, Farmers State Bank, a drug store, a garage, Cairo Café, Dove's Grocery, A. Runge Meat Market, and Henry Rathman's Harness Shop.

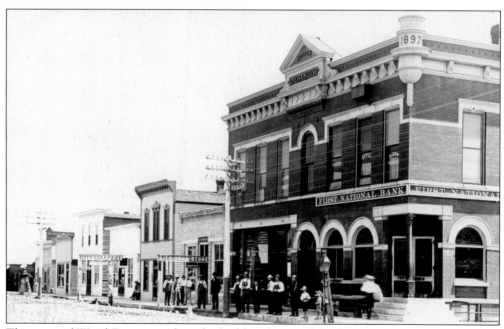

The town of Wood River joined in the building boom of the late 1800s. This view of Main Street, taken in about 1910, shows the impressive Moore Opera House (built in 1892) which housed the First National Bank. Also visible in the photograph are Jerry Bowen and Company, Diefenderfer Hardware, Curtis (painter), Fred Hollister Hooten Meat Market, a saloon, and Quakenbush Interest.

Two

BUSINESSES

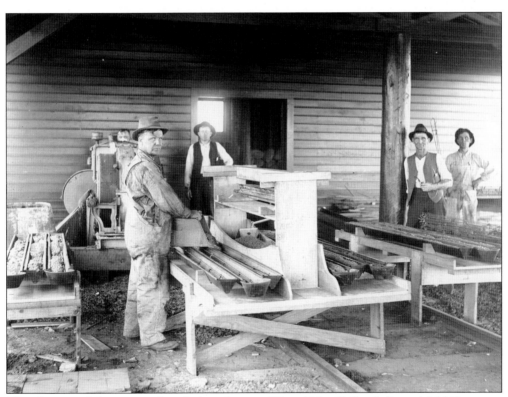

This photograph features unidentified employees of Grand Island's Staple Fence Mold Company, taken in 1918. The man at left, wearing overalls, is using a large metal scoop to pour a concrete mixture into molds for fence posts. The concrete fence posts were then used by the Union Pacific Railroad along their tracks in rural Hall County. A large concrete mixer can be seen behind the man wearing overalls.

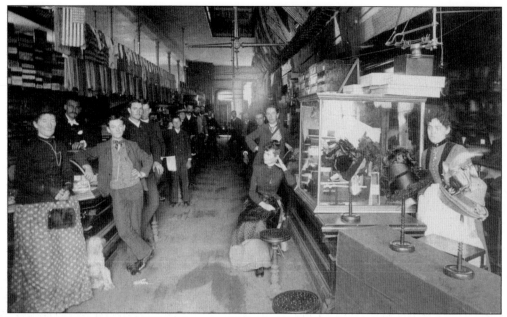

In this 1885 photograph, 17 people pose inside the S. N. Wolbach's Dry Goods Store, at the southwest corner of Third and Pine Streets in Grand Island. The department featured in this image is believed to have been on the second floor of the Wolbach Building. Elaborately decorated hats for women are displayed on the counter at the far right. The woman behind the hat counter is milliner Addie Hall.

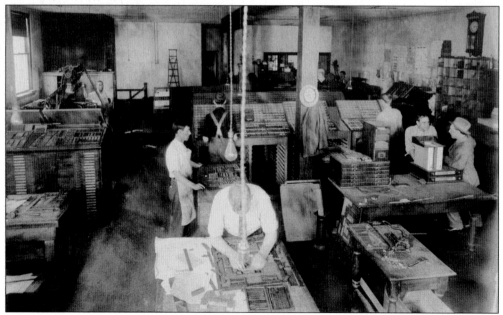

Several men are hand-setting the type for the *Grand Island Daily Independent*'s printing press in 1910. Started in 1870 by Maggie Mobley, the *Grand Island Daily Independent* is Grand Island's longest running newspaper. In 1910, the newspaper moved from its location in the Hedde Building on Third Street to a new one-story brick building in the 100 block of South Locust Street, likely where this photograph was taken.

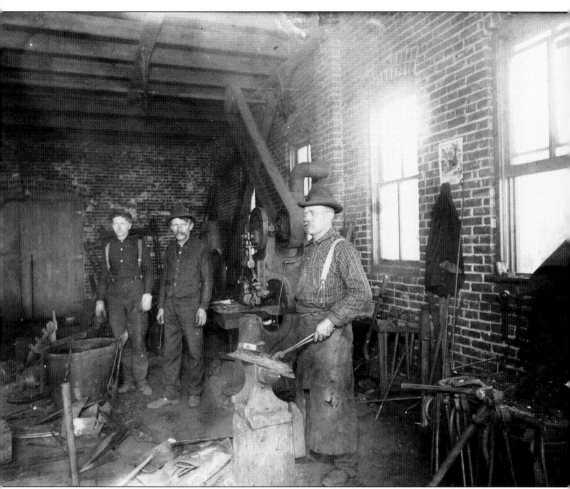

Business partners Edward Krall (center) and C. H. Gottlieb Heidkamp (right) pose with their employee Walter H. Bredemeir (left) inside their blacksmith and wagon repair shop in about 1908. The shop was located at 110 North Locust Street in Grand Island. Heidkamp, clad in a leather apron, is at work using a pair of tongs and an anvil.

Nine men and two boys pose in front of John Fonner's Livery Barn at 309 North Pine Street in Grand Island during the late 1870s. Also in the photograph are three horses, a surrey, and a two-wheeled pony cart. The bearded man wearing a light colored shirt with a dark vest and hat to the right of center is likely John Fonner, an early Hall County settler and businessman.

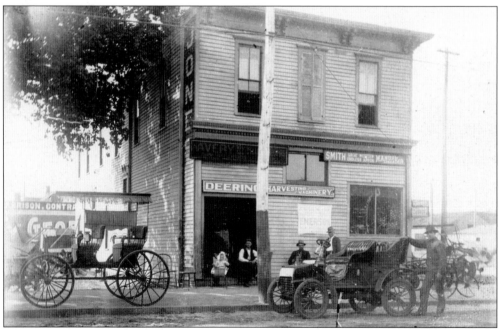

In about 1904, a buggy and an early automobile are parked in front of the H. L. Jones and E. S. Jones agricultural implement business. The business was located at 224 East Third Street in Grand Island. The name "Jones" can be seen painted on the side of the building. Other signs refer to farm equipment brands including names like Deering Harvesting Machinery, Avery Farm Implements, and Smith Manure Spreaders.

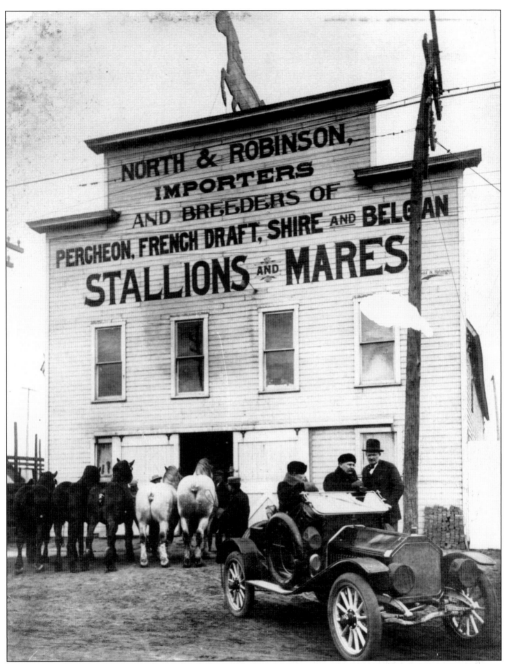

Taken about 1915, this photograph shows the Grand Island sales barn of North and Robinson Importers and Breeders. Operated by Chauncey North and William Robinson, the business gained a national reputation for breeding and importing quality Belgian, Percheron, and French draft horses. About 1900, North started a livery and sales barn in Cairo. Robinson soon joined him in business. In 1907, they built a large sales barn opposite the equally successful horse and mule dealers Bradstreet and Clemons Company on East Fourth Street in Grand Island. By 1918, Grand Island's horse and mule market was the second largest in the world.

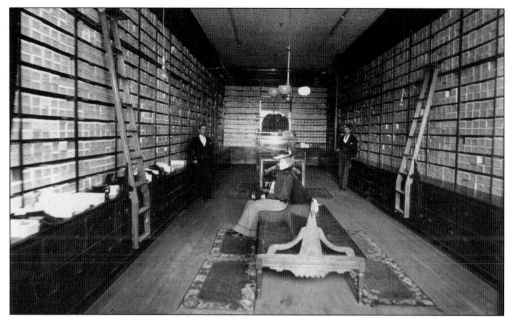

Taken about 1897, this photograph shows the interior of the Decatur and Beegle Shoe Store at 110 West Third Street in Grand Island. The store was 24 feet wide, 60 feet deep, and 16 feet high. Shoe boxes line the walls, floor to ceiling. A. A. Beegle, son of the store's owner, is standing at the far right. Store clerk Charles R. McElroy stands to the far left. The female customer is unidentified.

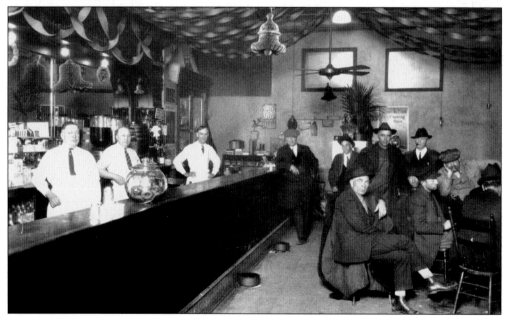

This c. 1920 photograph shows the interior of Buenger Soft Drink Saloon. It is an example of how former Grand Island saloons survived Prohibition between 1917 and 1933. Prohibition in Nebraska, under state law, began in 1917. Many former Grand Island saloons became "soft drink parlors." The overhead decorations indicate the photograph was taken during the Christmas season. Three bartenders stand behind the bar ready to serve the patrons root beer and sodas.

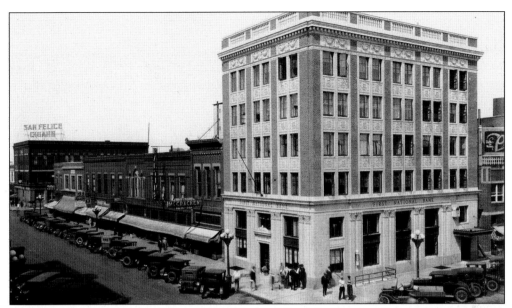

This photograph shows Grand Island's First National Bank Building in about 1927. Still standing at the northwest corner of Third and Wheeler Streets in Grand Island, it was completed in 1926 and expanded in 1965. Other businesses sharing the 200 block of West Third Street included: McCracken Drug Company, Martin's Department Store, Feinberg's Novelty Boot Shop, Piggly Wiggly Store, Grand Island Candy Kitchen, Woolworth's Five and Dime Store, and G. R. Kinney Shoes.

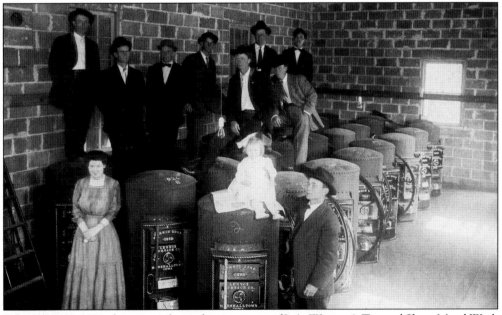

Taken May 14, 1911, this image shows the storeroom of J. A. Wingert's Tin and Sheet Metal Work at 224 East Third Street in Grand Island. The men are standing on Lennox Torrid Zone 026B furnaces manufactured in Marshalltown, Iowa. The child is likely Mildred Wingert, daughter of Jeremiah Albert "Bert" Wingert and Stella (Heath) Wingert, possibly the man and woman standing on the floor.

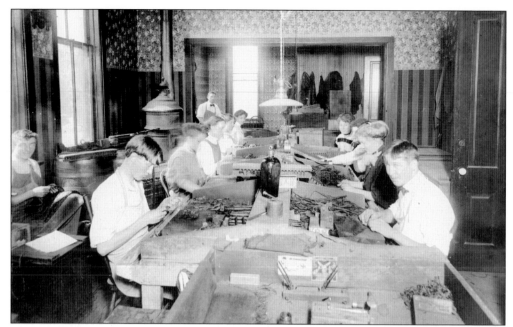

Nine employees, both male and female, are seated on either side of a long work table inside the Brandt Cigar Company in about 1915. The Grand Island cigar manufacturer was located on the first floor of the Grand Army of the Republic building at the time of this photograph. From 1898 to 1922, Grand Island boasted no fewer than eight cigar factories.

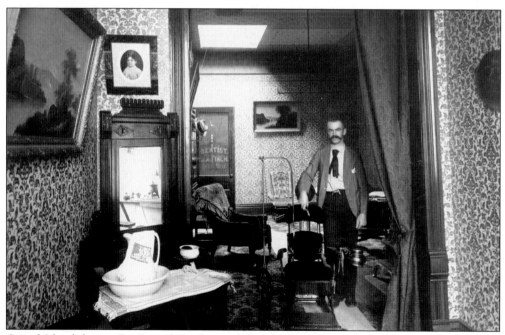

Grand Island dentist Dr. Daniel Finch stands beside the chair used for examining patients in this mid-1890s photograph. In his right hand, Finch holds a pair of dental pliers. A sign of the German influence in Grand Island, Finch has painted on his office door, visible at the back of the room, *Sahn Arzt*, which is German for "tooth doctor."

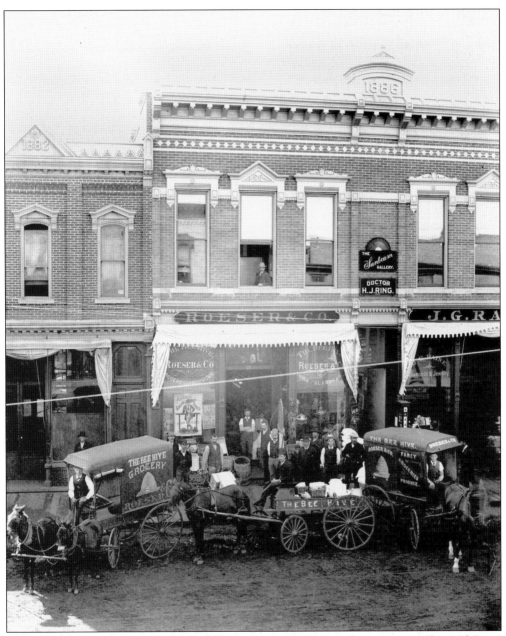

Taken about 1887, three mule-drawn delivery wagons with their drivers pose in front of Oscar Roeser's Bee Hive Grocery Store at 115 West First Street in Grand Island. About a dozen men can be seen standing on the boardwalk in front of the store. The two men standing in the doorway are Robert Freitag (arms folded) and Oscar Roeser (right and below Freitag, with mustache). Freitag was Roeser's business partner for a time. The man standing on the boardwalk with a loaded push cart is store employee August Meisner. The drivers of the wagon are, from left to right, Fred Roeser, Albert Roeser, and Rudolph Bock. Fred and Albert were brothers of Oscar. The man visible in the second floor window is believed to be Dr. H. J. Ring. In 1926, the Bee Hive name changed to Oscar Roeser and Sons. It remained in operation until it closed in 1940.

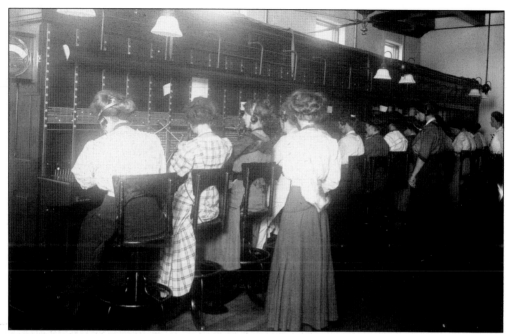

A line of young women work the switchboard at the Nebraska Telephone Company, Grand Island Division, in 1911. Three chief operators stand at attention behind the seated operators. Completed in 1911, the telephone company's building was located at 219 North Walnut Street in Grand Island.

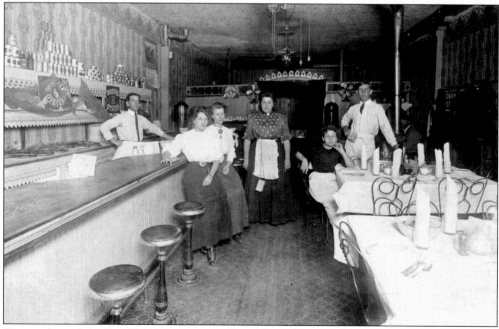

Six members of the Bon Ton Restaurant staff pose for a photograph in November 1904. The Bon Ton was located at 222 West Third Street in Grand Island. An order ticket book hangs from a chain attached to the apron of the woman in the center of the image. Several oyster advertisements can be seen all around the restaurant. Oysters were a popular delicacy around 1900.

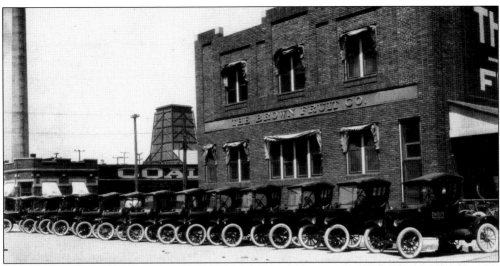

The Brown Fruit Company's fleet of Model T Fords is parked in front of its headquarters at 355 North Pine Street in about 1920. The company was started in 1914 by E. L. Brown, C. C, Kelso, J. D. Webster, and B. B. Farrell. The two-story brick warehouse and office was built in 1916.

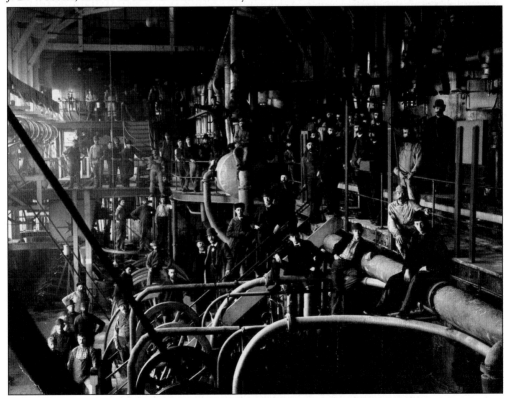

Officials and workers of the Oxnard Beet Sugar Company, along with Grand Island dignitaries, pose among the maze of machinery on opening day of the Grand Island factory. Completed in 1890, the factory was located at the west end of Koenig Street. Designed by Grand Island architect Julius Fuehrmann, the factory building was 292 feet in length, 85 feet wide, and equal to a four-story structure in height.

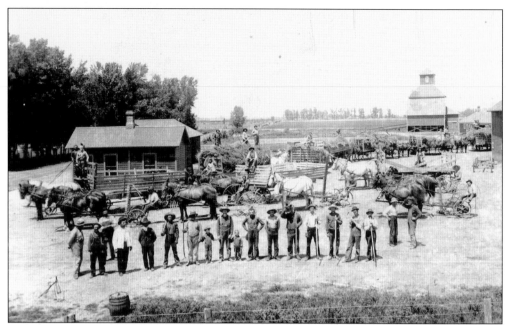

In the late 1890s when this photograph was taken, haying at the Robert Taylor ranch near Abbott, Nebraska, was a big operation. Gathered for this photograph are six full hay wagons, three empty wagons, three mowers, two hay rakes, at least 37 men, two young boys and about 28 horses and mules.

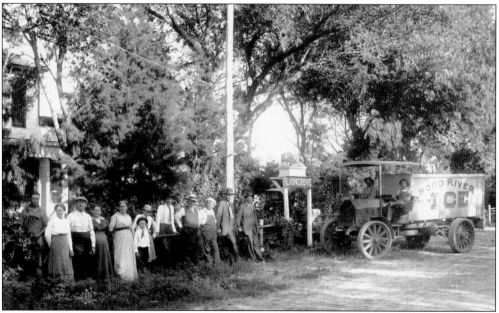

A dozen people pose near the entrance to the resort known as the Lion Grove in about 1916. Located south of Grand Island on the Wood River, Lion Grove was opened in August 1893 by William Lindermann. After Lindermann died in 1902, Lion Grove was passed to John C. C. Hann (pictured third from left). The delivery truck (right) belonged the Wood River Ice Company, operated by brothers Gus, William, George, and Fred Tavenet.

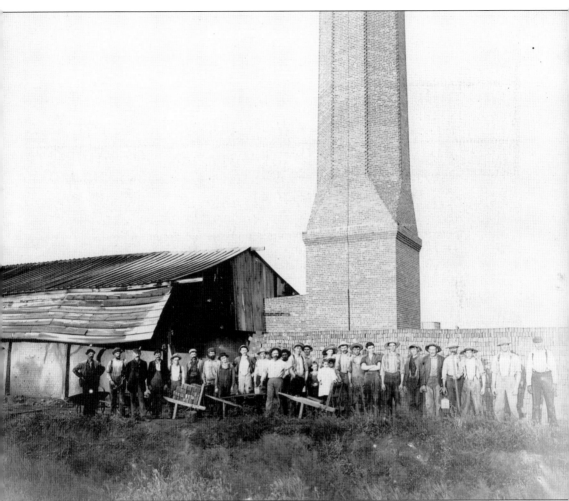

In the early 1900s, workers of the Doniphan Brick Works pose near the base of the 155-foot high smokestack of the drying kiln. Located along the St. Joseph and Grand Island Railroad on the northeastern edge of Doniphan, the brick works began operation in 1885 under Edwin Kerr, Walter King, and Henry Collins. The factory closed in 1926 and the buildings were torn down.

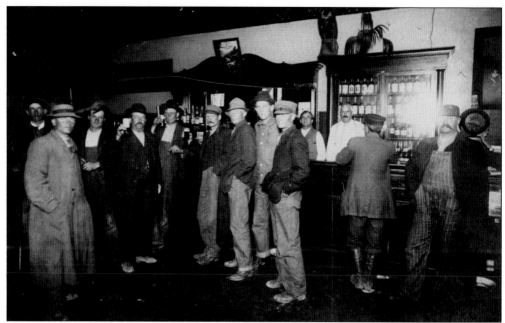

The George Flebbe Saloon served the citizens of Cairo through the first few decades of the 20th century. Pictured here around 1910 are, from left to right, Mut Vierk, George Hulme, George Myers, Link Omer, Lou Ruzicka, Henry Stoeger, Earl Van Winkle, unidentified, John Orndorff, unidentified, unidentified, Ed Williamson (with his back to the camera), and ? Jensen.

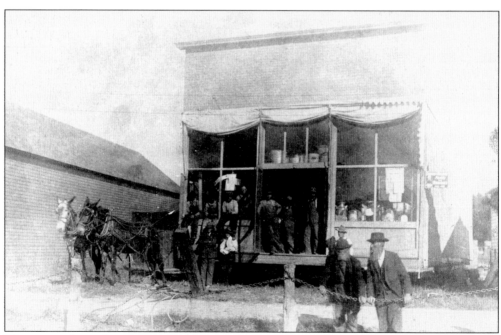

This image shows the moving of A. S. McAllister's General Store in Cairo in about 1905. The building has been raised off the ground and a team of mules stands off to the left. Operating in Cairo as early as 1887, McAllister's store suffered devastating fires in both 1909 and 1915. After reconstructing the store a third time, George and Callie Dove acquired the store in 1916.

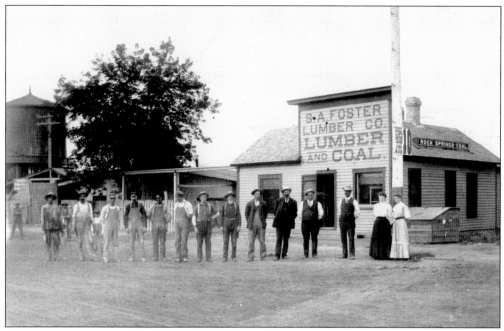

The S. A. Foster Lumber Company was located near the tracks of the Union Pacific Railroad in Wood River. A sign on the lumber company's roof reads Rock Springs Coal, likely indicating they sold coal mined from the Rock Creek coal mines of Wyoming. A large water tower can be seen at the far left. This photograph was taken in 1907.

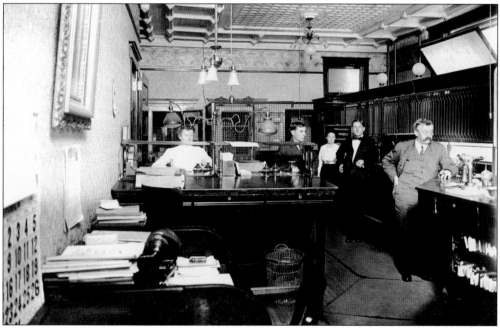

Pictured here is the Citizen State Bank of Wood River. According to the calendar on the wall at the left, this image was taken in October 1912. It was taken from behind the teller's counter. The three men and two women featured in this photograph are not identified. In 1912, Patrick Hoye was the vice-president of the bank.

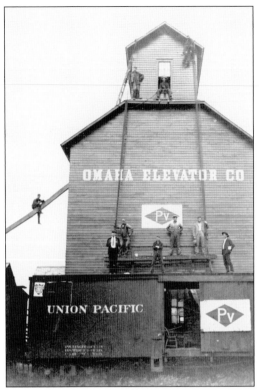

Pictured here, the Omaha Elevator Company was located in Alda along the Union Pacific tracks. Grain elevators allowed rural Hall County farmers to sell and ship their cash crops coast-to-coast via the railroad. They were a vital part of the rural economy. During its early years, Alda was able to support three different elevator companies: the Trans-Mississippi Elevator, the Omaha Elevator Company and the Farmer's Elevator Company.

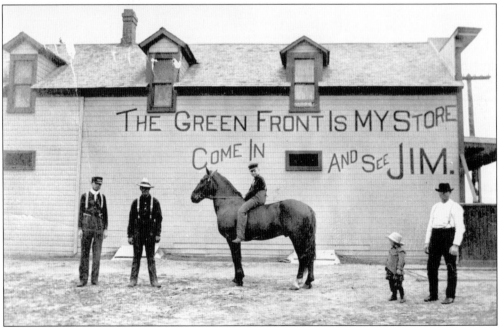

Painted on the side of this general store in Alda is "The Green Front is My Store. Come In and See Jim." Jim was James W. Modesitt, who opened a general merchandise store in about 1888. He remained in charge for 20 years and sold it about 1906. From there, the store passed through many hands, but retained the same name. Seen here is the 1911 structure.

Three

SCHOOLS

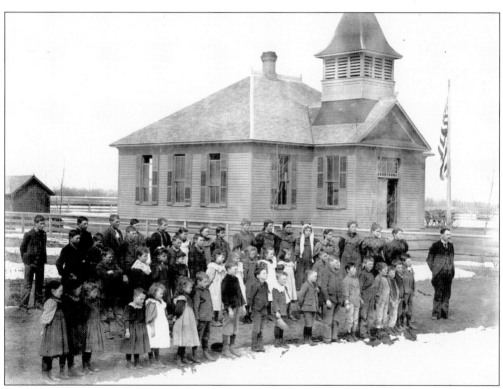

Forty-nine students and their teacher, John B. Reaugh, pose in front of Hall County School District 25, Schauppsville School. Taken on February 22, 1897, this photograph was likely taken as part of a ceremony honoring George Washington's birthday. The Schauppsville School was located west of Grand Island between Alda and Wood River, in the southeast corner of Wood River Township. The school's name traces to John G. Schaupp, who in 1874, established a water-powered flour mill near the school on the Wood River. A small settlement grew near the mill and became known as Schauppsville.

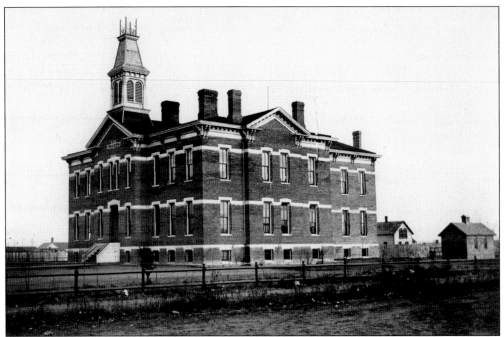

Grand Island's old Dodge School once stood in the 300 block of West First Street. Completed in 1879, it was the city's first brick schoolhouse. This view is from the northwest and was taken after the 1884 addition was made to the south end of the building. Best remembered as an elementary school, Dodge School served all grade levels until the new high school was completed in 1908.

A group of teachers poses in front of the east entrance of Grand Island's old Dodge School in about 1900. Included among the group is Grace Abbott. After teaching high school in Grand Island, Abbott went on to a distinguished national career in social welfare. School janitor W. T. Alden stands at the far left with the broom. John Matthews, the high school's principal, stands at the far right.

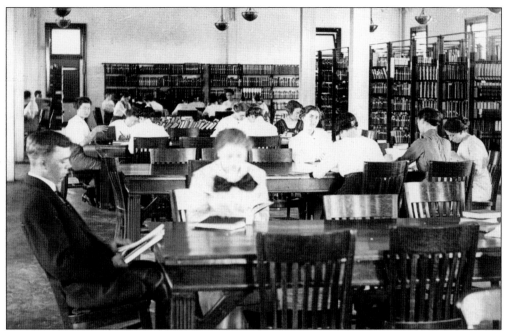

Grand Island High School students study at tables in the school library in about 1912. This building opened in 1908 in the 900 block of Walnut Street. It was used as a high school until 1925 when it became Walnut Junior High School and a new high school was opened in the 500 block of North Elm Street.

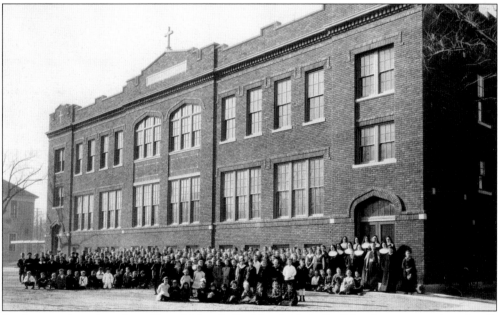

Students and teachers from Grand Island's St. Mary's Catholic School pose near the school's entrance in the early 1920s. This two-story brick building was completed in 1920, replacing a two-story frame structure built in 1894. Both schools were located on West Division, south of the original St. Mary's Church. The corner of the frame school can be seen in the distance at the far left.

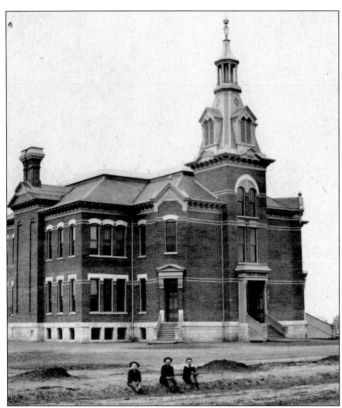

Located on the corner of Fifth and Sycamore Streets, the first Howard School building opened in 1884. It was an eight-room, two-story, brick structure that served as Grand Island's north-side elementary school. The school was named for Blake C. Howard, general foreman at the Union Pacific Railroad's shops and an active member on the school board. It was abandoned in 1954, with the opening of a new Howard school.

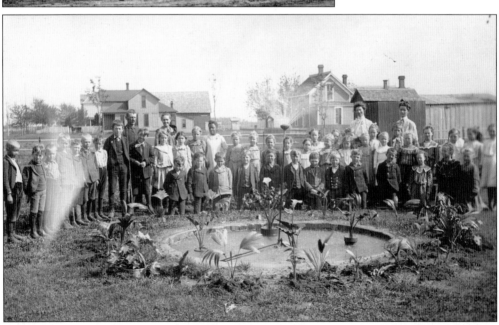

A large group of children and their teachers pose in front of a pond likely near Grand Island's Wasmer School in about 1905. A fountain sprays water from the center of the pond and freshly planted plants surround the pond. Wasmer Elementary School was built in 1886 in the 1600 block of West Division Street.

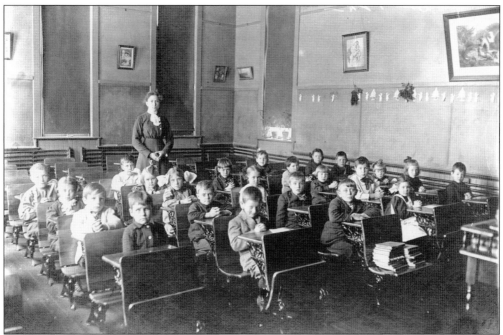

Grand Island's Platt School opened its classrooms in 1888. It was named in honor of Nathan Platt, a Union Pacific Railroad bookkeeper and school board member who served as board president. The building, seen below, was located at Seventh and Elm Streets. In the top image, Edna Switzer's third grade class sits at attention in about 1907. Handmade Christmas decorations can be seen hanging on the wall at right.

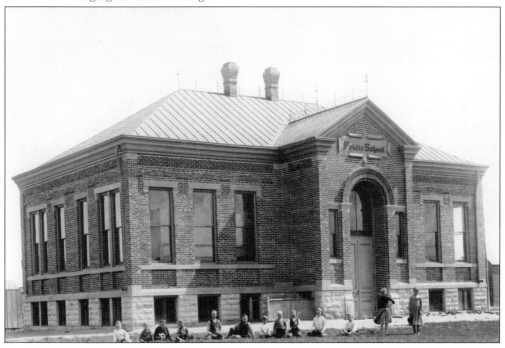

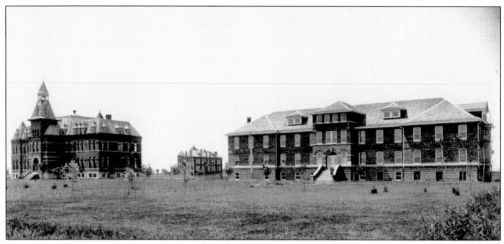

The Grand Island Baptist College opened in 1892 at the site of today's Grand Island Senior High School but closed in May 1931. At the far left is the school's main building of classrooms and administration offices. Grand Island Hall, used as the men's dormitory, can be seen in the distance. The building at right is Hibbs Hall, built in 1905 as a women's dormitory.

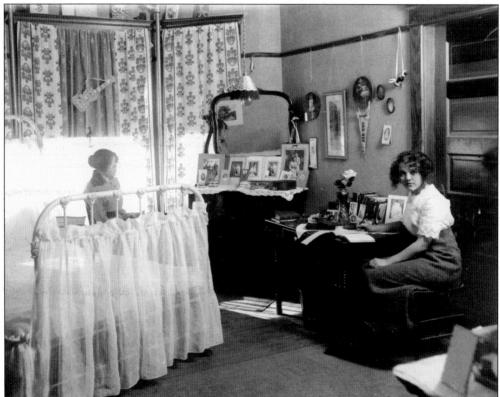

Taken in about 1913, this photograph captures two young college students at home in their Grand Island Business and Normal College dormitory at 721 West Second Street. The experiences of these two unidentified women were probably not that different from today's college students away from their families for the first time. Dorm rooms, however, have changed much since this photograph was taken.

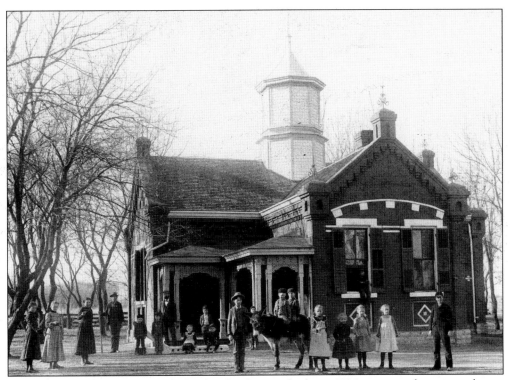

These nearly identical one-story brick schools were built in 1886 to serve the east and west ends of Hall County School District 1. They were designed by Grand Island architect Julius Fuehrmann and built by contractor Fred Lehman for a total cost of $4,515.07. In 1888, District 1 was divided into two districts. The east end school (above), or Seedling Mile School, became District 74, seen above in the mid-1890s. The west end school (below), also known as Stolley School, remained District 1. The image of Stolley School is believed to have been taken in the late 1880s, possibly during a picnic celebrating the opening of the school.

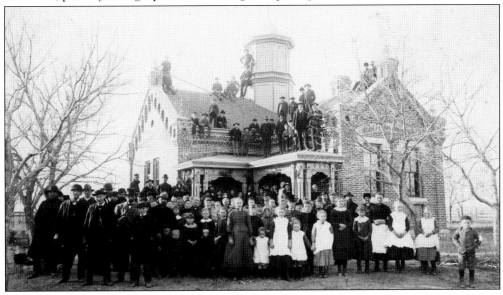

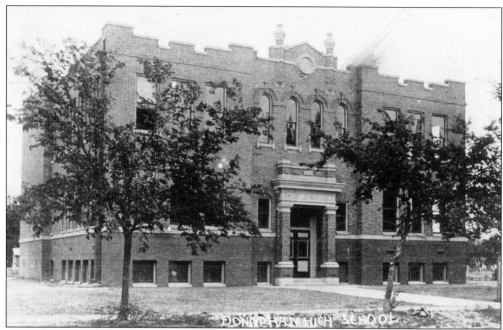

This two-story brick building served as the high school for the community of Doniphan. The high school was part of Hall County School District 26. This image was taken from a photographic postcard sent to Enid, Ohio, in 1917 from Grand Island.

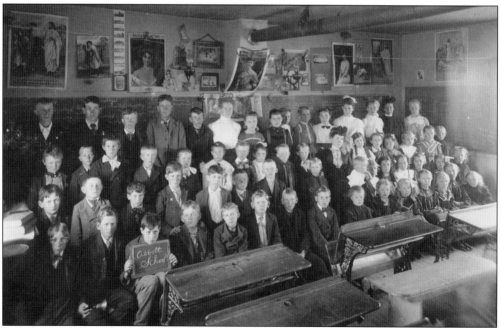

This photograph captures the students and teachers of Hall County School District 54, also known as Abbott School. It was taken on April 17, 1906, by Grand Island photographer Julius Leschinsky. Abbott was a small community located about seven miles northwest of Grand Island. Amazingly, written on the back of this photograph are the names of all 61 students, too numerous to mention here.

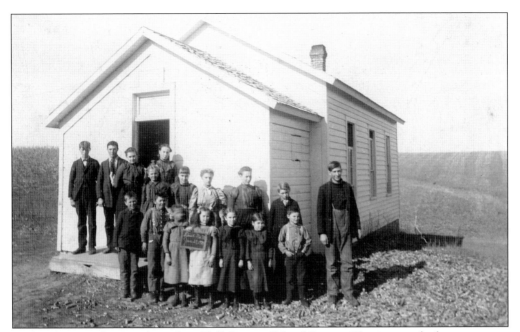

In this photograph, 17 students from Hall County School District 70 pose outside their one-room schoolhouse. This small one-story frame school was also known as Bluff Hollow. It was located in Cameron Township, northwest of present-day Wood River. The young girl in the center of the image holds a slate with the school district and the date January 29, 1900, written in chalk.

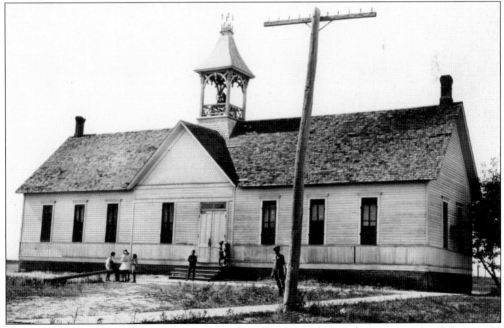

Seen here about 1910 is the one-story frame schoolhouse used by Hall County School District 72 in Cairo. The original building, which opened in 1886, was moved to the site on the west side of Cairo. It included just the center section under the bell tower. Additions were added in 1892 to the south and in 1894 to the north. A new brick school replaced this structure in 1915.

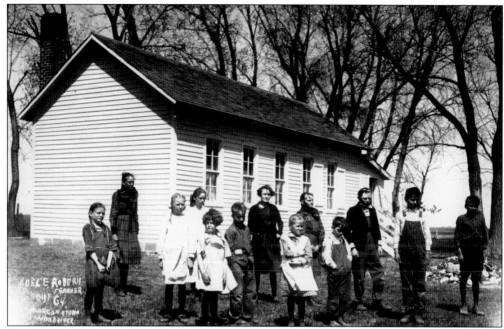

Adele Roberts, along with her 12 students from Hall County School District 64 pose in front of their one-room schoolhouse on a windy day in 1924. Located in the far northwestern corner of Hall County, District 64 operated from 1880 into the 1920s. The original school was built in 1880 out of sod. The frame building seen here replaced the sod school in the 1890s.

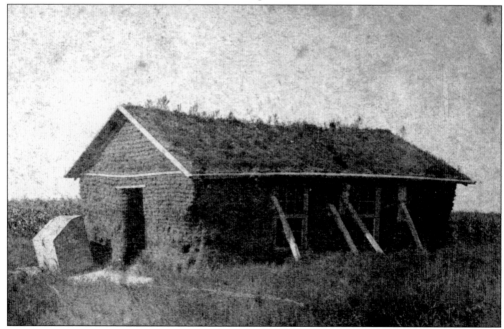

Known as the Runelsburg School, Hall County School District 36, it was located about one mile east and one-half mile north of Cairo in Mayfield Township. The one-room, sod structure is believed to have been built in about 1874 and was used as a school until about 1884. Logs have been used to prop up the sod wall and grasses are growing from the roof.

Four

THE HOME

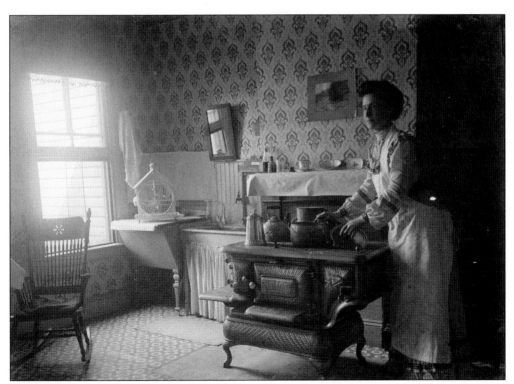

This *c.* 1905 image illustrates a simple kitchen. The unidentified lady wears a full-length apron while she stands tending the food on her Paragon B six-burner range, which is hooked to a chimney through an old fireplace. To the left of the stove are two sinks, one with running water, and the second, deeper covered sink holds a canary cage and has splasher fabric pinned behind it.

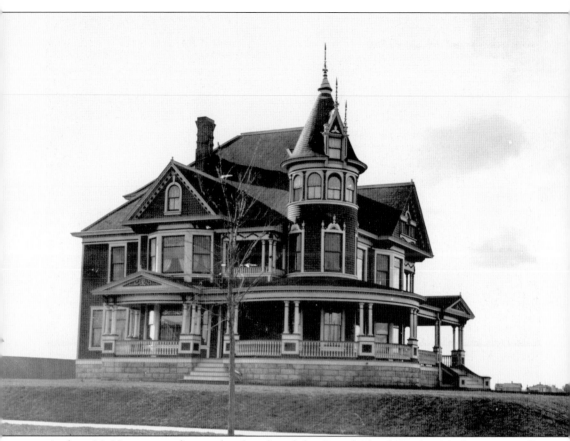

Andrew M. Hargis, president and cofounder of the Grand Island Business College, originally built this home, completed in 1899, at the corner of Second and Lincoln Streets in Grand Island. Work on the house, originally painted a dark green, began in 1898 and was completed in 1899. Dirt was moved to the property to elevate the house above the sidewalk and street level. The Hargis family occupied the house until moving to California in 1913. The house passed through several private owners including the Christ Lutheran Church. The Grand Island Women's Club purchased the house in 1953. They continue to occupy the Hargis house to this day.

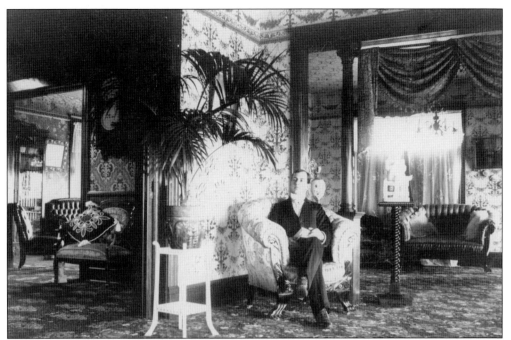

Andrew M. Hargis proudly sits in the parlor of his beautiful home (seen on previous page). Taken in 1892, Hargis is posed in a fabric-covered chair with rolled arms. A large potted palm can be seen to the left of him.

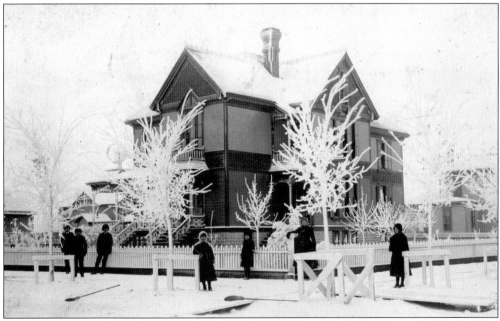

Children stand outside the O. A. Abbott family residence. Completed in 1886, the house stood on the corner of First and Cleburn Streets. A prominent Grand Island attorney, Abbott was the first lieutenant governor of Nebraska from 1877 to 1879, and one of only nine men elected to both of the state's constitutional conventions of 1871 and 1875, helping to shape the state's structure of government. The house was razed in 1973.

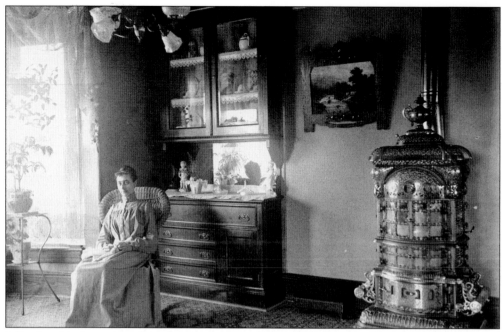

Julius Leschinsky captured nearly every aspect of life with his camera during his long career as a professional photographer. Luckily, he liked to take his work home. The abundance of quality interior images from the Leschinsky house allows a rare and intimate look inside an early-1900s home. In the photograph above, Julius's wife, Minnie Leschinsky, sits in the family's parlor working on what appears to be needlework. Numerous house plants can be seen at left and an ornate parlor stove to the right. Julius's youngest son Armand, below, plays with a toy truck near a bookcase full of books in the bedroom he shares with his older brother Oswald. At the time of these images, the Leschinsky's home was located at 522 West Koenig Street.

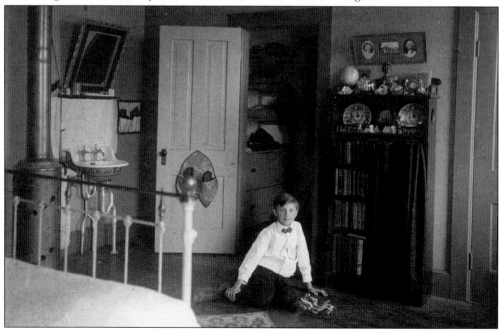

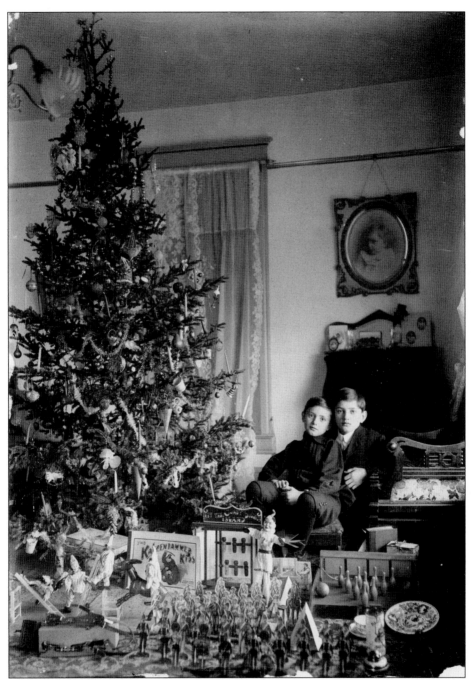

The Leschinsky family had a unique family tradition for the time, but one that we take for granted today. Nearly every year from about 1896 to about 1920, Julius, Minnie, Oswald, and Armand would pose with the family Christmas tree. In this photograph, Oswald (right) and Armand (left), pose near the family Christmas tree in about 1900. Numerous gifts are spread out under the tree, including acrobatic clowns, toy soldiers, a bowling game, and a board game. The Leschinsky's tree is decorated with tinsel, blown glass ornaments, and paper cornucopias. Candles have been clipped to the tree's branches.

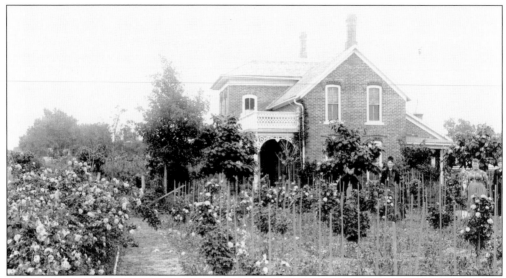

During the late 1880s and 1890s, Gustave and Kate Koehler's (seen third from left) rose garden was considered one of the finest in Nebraska. The Koehler's home and garden were located on South Locust Street, west of today's Pier Park. According to an 1894 *Grand Island Independent* article, the Koehler rose garden featured over 500 varieties of roses, some of which were imported from Germany. This photograph was taken in about 1893.

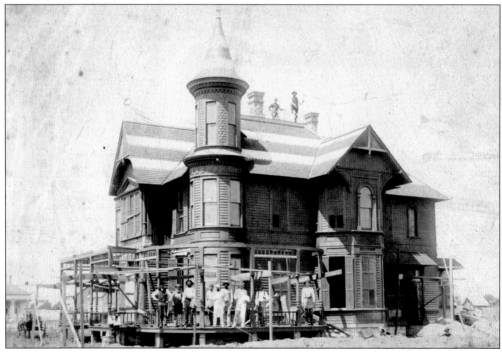

Pictured here while under construction is the Alexander H. Baker home, which once stood near the northwest corner of West First and Eddy Streets in Grand Island. Designed by architects C. C. Rittenhouse and G. F. Brage, this grand Queen Anne–style home was completed in 1887. A prominent business leader in the 1890s, Baker's interests included the street railway company, the canning factory, and a cigar factory. The house was razed in September 1959.

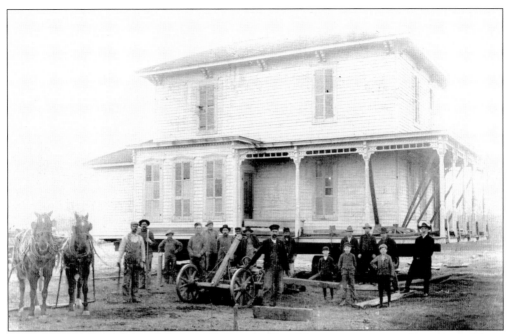

This photograph is likely of George W. Broadwell and his crew moving a house, possibly in Grand Island. Broadwell is listed as a house mover in the Grand Island City Directories from 1896 to 1911. He served on the Grand Island City Council for 13 years. Grand Island's Broadwell Avenue was named after him in 1911.

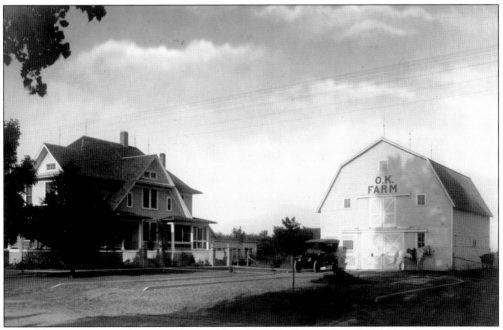

Seen here in 1920 is the O. K. Farm, the home of the Fonner family. The farm takes its name from the O. K. Store that early Hall County settlers fortified to protect themselves against Native American attacks. At the time of this photograph, it was the home of Gus Fonner, who once traveled with Buffalo Bill Cody's Wild West Show, among many other lively life-long pursuits.

51

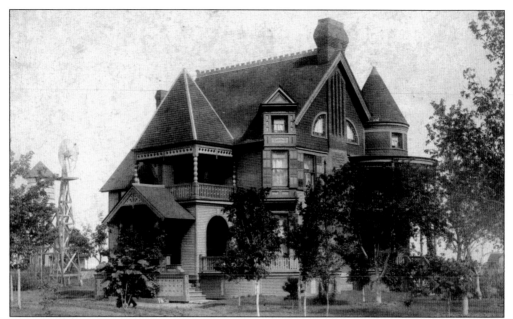

Completed in 1888, this elegant Queen Anne–style residence was the home of Thomas Oliver Cromwell Harrison. It was located at the northwest corner of Thirteenth Street and Lafayette Avenue in Grand Island. Harrison served as judge of the Ninth Judicial District from 1887 to 1894, and then the Nebraska State Supreme Court from 1894 to 1900, serving as chief justice his final two years. The house was torn down in the 1940s.

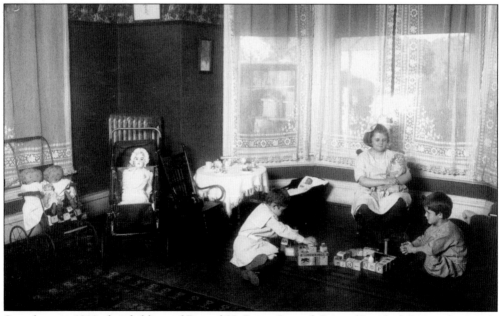

Seen here in 1911, the children of Bayard H. Paine Sr. and Grace (Bentley) Paine play inside their home at 1018 West First Street in Grand Island. The children are, from left to right, Bayard Jr., Alice, and Charles. The boys play with wooden blocks on the floor. Alice holds a porcelain doll. More dolls are seated in the two toy strollers at left. A child-size table is set for make-believe tea.

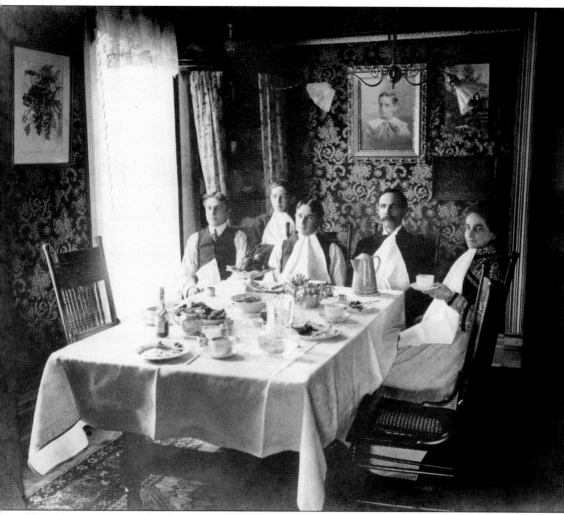

The August C. Meyer family is seated around the dining room table in their home on Koenig Street in Grand Island. A native of Switzerland, August Meyer established a fine jewelry store in Grand Island in 1886. This photograph captures a typical upper-middle class family meal in about 1900. A bottle of ketchup is visible on the lower left corner of the table. From left to right, the family members are Robert, Ernest, August H., August C., and Elizabeth.

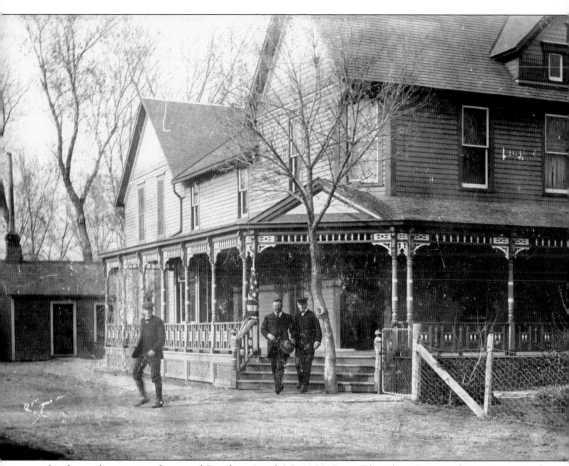

In the early morning hours of Sunday, April 26, 1903, Pres. Theodore Roosevelt's train arrived in Grand Island. During his two-day visit, President Roosevelt enjoyed a 25-mile horseback ride around Hall County. This photograph captures the president leaving Robert Taylor's ranch near Abbott after dining on a light lunch. Taylor was a wealthy rancher, who became known as the Sheep King of Nebraska.

Sylvester and Virginia Deffenbaugh stand with their horse and carriage outside of their home on Said Street in Cairo. Sylvester held quite the array of jobs in Cairo, ranging from postmaster in 1914, to high school janitor in 1917.

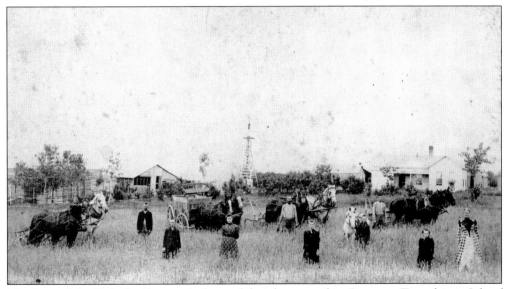

Members of the Cady family pose in front of their homestead in Cameron Township in July of 1892. Pictured are, from left to right, Fred, Jeff, Matilda, Warren E., Grace, John, Ed, Carrie, and Sarah. Four teams of horses are hitched to various pieces of farm equipment. In the distance, a windmill is visible.

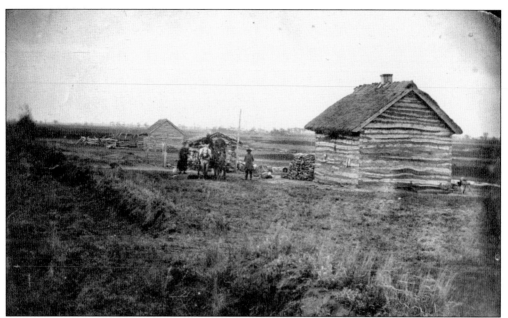

The homestead of Hall County's original settler, Heinrich Egge, was located northeast of Grand Island. This photograph was likely taken during the late 1860s or early 1870s. The small log cabin at right has a thatched roof. In the center of the image, a small group of people pose with a horse-drawn wagon. The mound of earth running across the Egge property was a fire berm used to slow prairie fires.

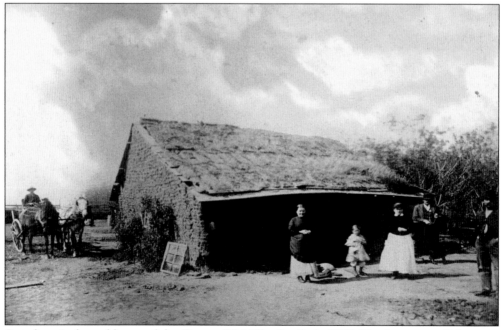

Seen here is the sod home of the George W. Miller family in 1887. The house stood about six miles north of Wood River. At right, the two men, two women, and the young girl are not identified. The man in the wagon at left is Fred Slussen. A glass window pane can be seen leaning against the corner of the sod home.

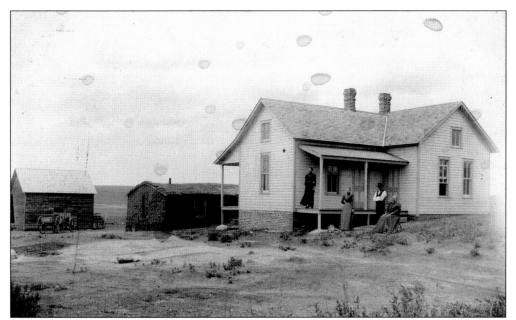

The exact location of this Hall County farmstead is unknown. This early 1890s image illustrates the progression many farms took. A newly-constructed frame home stands next to a sod house. When homesteaders arrived in Hall County, they built their homes of materials most available, usually sod or cottonwood logs. As the farm prospered and better building materials became available, larger, more civilized homes were built.

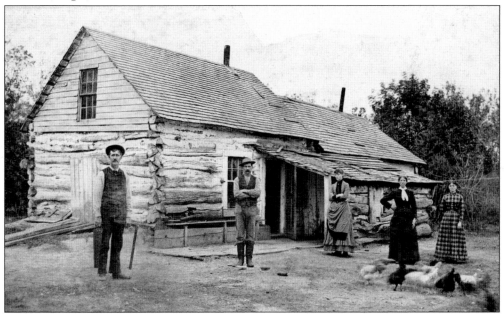

Two unidentified men and three women pose in front of the O'Keefe homestead in the late 1880s. The farm was located west of Wood River in Hall County's Jackson Township. The window visible at left under the log cabin's peaked roof likely opened into a sleeping loft. Numerous chickens peck the ground near the ladies. The man at left is holding a hand saw and carpenter's square.

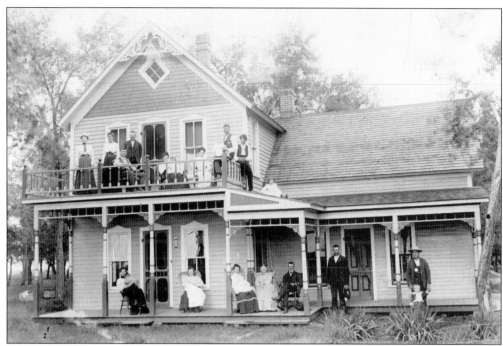

The whole Balcom family is gathered at the family farmstead two miles south and three miles east of Cairo. They are celebrating the 35th wedding anniversary of Henry S. and Betsy Balcom on April 20, 1906. Betsy is the fourth woman seated on the lower porch. Henry, a semi-professional photographer, is likely off-camera taking the photograph.

Seen here in about 1915 is the two-story residence of Dr. Clement A. Stone in Doniphan. Stone's offices were located on the second floor of the Stone Building. He served as Doniphan's physician and surgeon.

Five

CHURCHES

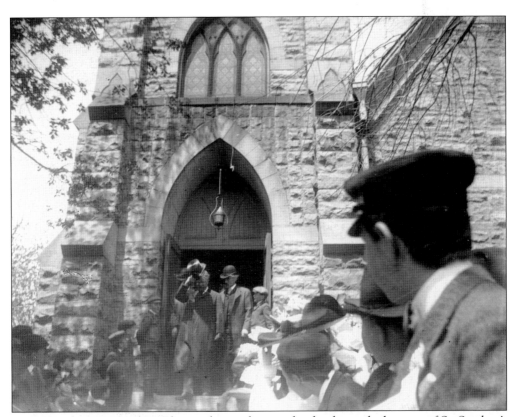

Pres. Theodore Roosevelt tips his top hat to the crowd as he descends the steps of St. Stephen's Episcopal Church in Grand Island during his two day visit in April 1903. Having requested no special treatment, the president and his party attended a typical Sunday service at St. Stephen's before taking a 25-mile horseback ride through Hall County. The following day, 800 school children lined the parade route that took President Roosevelt to the corner of Second and Walnut Streets where he broke ground for the new library.

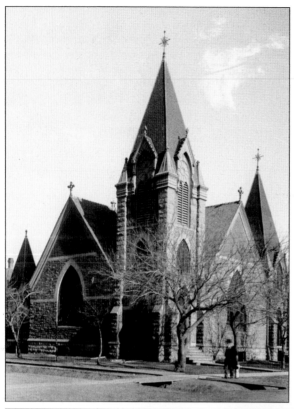

St. Stephen's Episcopal Church (left), at the northeast corner of West Second and North Cedar Streets in Grand Island, opened for worship on July 7, 1889. The landmark English Gothic structure was designed by Grand Island architects C. C. Rittenhouse and G. F. Brage. The structure is built of red granite from Colorado and trimmed in grey sandstone from Wyoming. The 1889 church replaced the first St. Stephen's Episcopal Church, a frame building completed on the same site in 1871. The photograph seen below is of the St. Stephen's choir, who took part in the Sunday, April 26, 1903, service attended by Pres. Theodore Roosevelt.

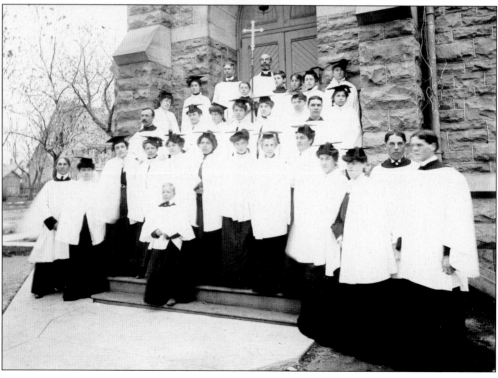

This 1890s photograph is of Grand Island's old First Methodist Episcopal Church. The large frame church with a stone foundation once stood at 507 West Third Street. The congregation began holding services in this building in 1889 while only the basement was completed. The First Methodist congregation became part of today's Trinity United Methodist Church.

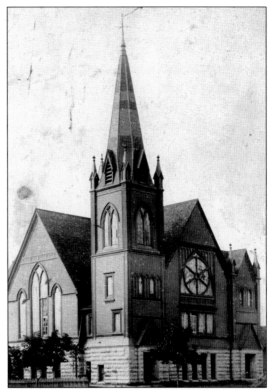

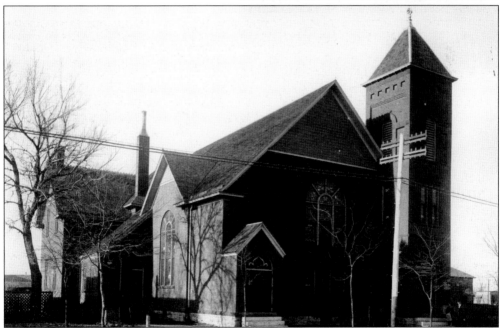

This brick church was formerly located at the northwest corner of Third and Eddy Streets in Grand Island. It was built in 1888 and 1889, and was originally the Immanuel Baptist Church. In 1900, First Christian Church purchased the structure. The church was torn down in September 1961, to make way for a parking lot.

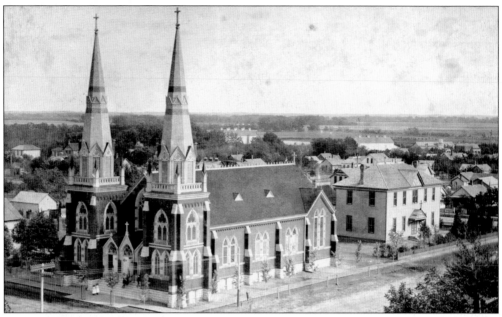

This mid-1890s bird's-eye view shows Grand Island's St. Mary's Catholic Church on the southeast corner of Elm and First Streets. The brick Gothic-style church was designed by architect Julius Fuehrmann. Work on the structure began on August 2, 1888, and was completed by July 1889. The church was used until the completion of St. Mary's Cathedral in 1928. The two-story frame structure behind the church was the church's first parish school, completed in 1893.

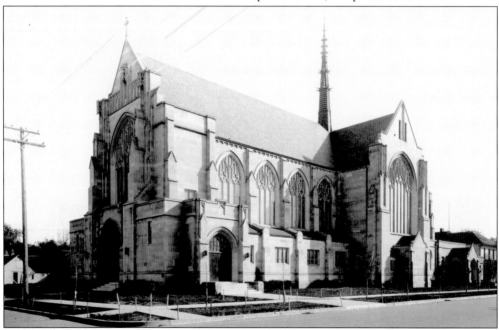

The Cathedral of the Nativity of the Blessed Virgin Mary is located at the southwest corner of Cedar and Division Streets in Grand Island. Architects Henry Brinkman and J. Stanley Hagen of Emporia, Kansas, created it as a scaled-down model of the French cathedral Le Sainte Chapelle in Paris. Made of Bedford limestone from Indiana, the cathedral was consecrated on July 5, 1928.

Ten members of the First Baptist Church's "Busy Worker" girls Sunday school class pose with their teacher, Charles Scarff, in 1885. The First Baptist Church came to Grand Island as a result of the efforts of the American Baptist Home Missionary Society. In 1888, the Grand Island congregation completed its church at the northeast corner of Seventh and Sycamore Streets.

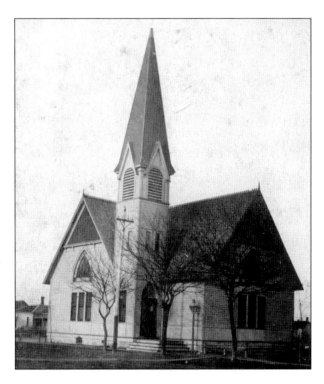

Seen here in about 1900, the First Congregation Church was located at the corner of Sixth and Kimball Streets in Grand Island. The cornerstone for the original frame building was laid on October 18, 1887. In 1915, the church underwent extensive alterations. The building was raised three feet above its former level to make way for a larger basement, and the entire structure was covered with pressed bricks.

Members of Grand Island's Presbyterian Missionary Society pose at the home of the Reverend J. T. Paterson around 1910. A small frame house can be seen in the background. Several of the women hold purses and a woman in the center of the front row holds a wooden gavel.

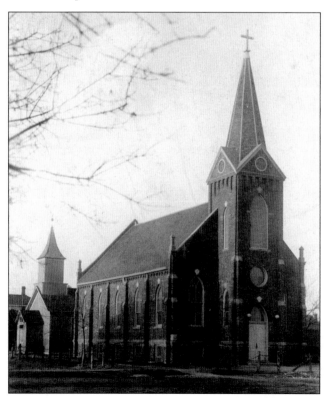

Grand Island's St. Paul's Evangelical Lutheran Church, located on the northeast corner of Seventh and Locust Streets, was built in 1908 by local contractors Henry Falldorf and Otto Kirschke. The congregation's old frame church can be seen behind the new brick structure. The frame church originally belonged to the United Brethren congregation. The Lutherans acquired and moved the building in 1884.

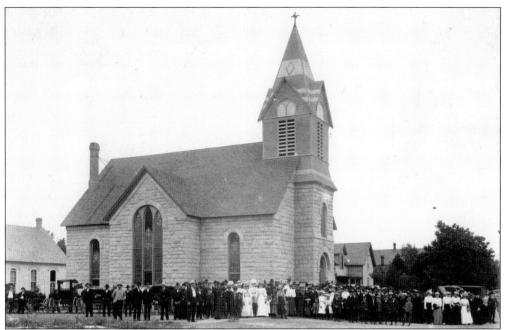

Dressed in their Sunday finery, members of Grand Island's Trinity Evangelical Lutheran Church, known in German as *Evangelische Lutherinche Dreienigkeit Kirche*, pose for this photograph following the 10:00 a.m. service on July 30, 1899. At this service the church's new pipe organ was dedicated. Built between 1894 and 1896, the limestone church still stands at the northeast corner of East Second and North Vine Streets and is on the National Register of Historic Places.

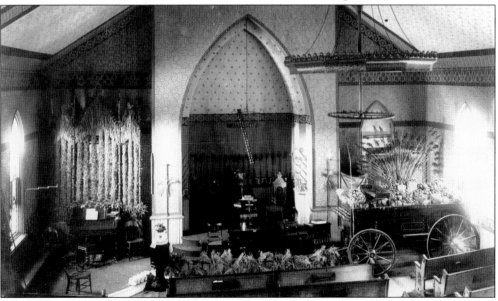

Taken from the balcony of St. Paul's English Lutheran Church in Grand Island, this photograph shows the church decorated for a "Harvest Home Festival" held on Sunday, September 27, 1896. Dedicated in 1886, this church stood at the southwest corner of Second and Cedar Streets. Grain was used to create the 14-foot high "pipes" above the organ (left). A Studebaker farm wagon (right) is loaded with a bounty of produce.

The First Church of Christian Science opened in Grand Island on October 31, 1899. Its first edifice was located on South Pine Street, but experienced an increase in members that made it necessary to relocate to a new building in 1912. Seen here is the 1912 building, located on the corner of Greenwich Avenue and Third Street.

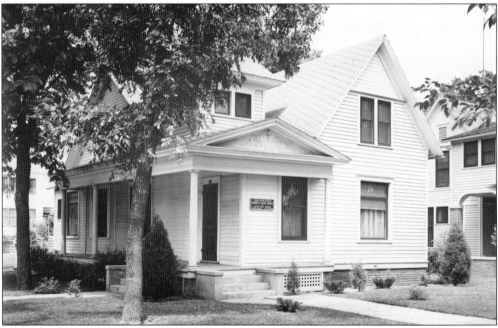

A small plaque near the front door of this two-story frame residence indicates that it is the home of Grand Island's Church of Jesus Christ of the Latter Day Saints. This Locke Collection photograph shows the 722 West Koenig Street location that the church moved to in 1936. (Locke Collection: courtesy of Steven L. Fuller of Bailey Photography and Stuhr Museum of the Prairie Pioneer.)

Seen here is the original chapel at the Nebraska Soldiers' and Sailors' Home in Grand Island. Construction on the framed church with a bell tower is believed to have been completed in 1893. It was located southeast of the home's main building. The pews installed in the church in 1893 could accommodate 200 people.

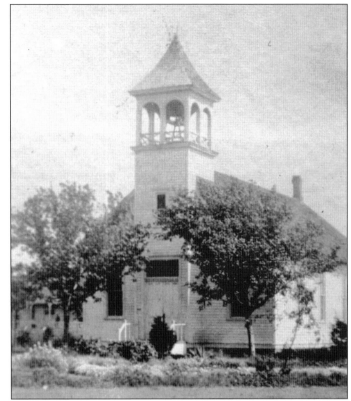

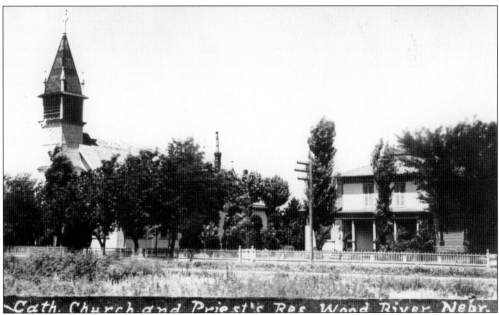

The first public worship services in Hall County were held by the Catholic Church of Wood River in the house of Anthony Moore in 1861. Wood River's first Catholic Church was built out of logs in 1868. Seen here is the Catholic church building which was erected in 1885. This image, likely taken in about 1915, also shows the priest's residence at right.

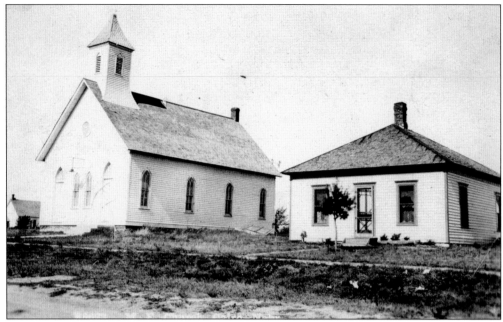

This c. 1910 photographic postcard shows Cairo's United Methodist Church and parsonage. The small frame church was originally built as the Burwick Methodist Episcopal Church. It was located two miles south of Cairo on the James Hulett farm. When the railroad arrived in Cairo in 1886, the congregation decided to move the church into the new town.

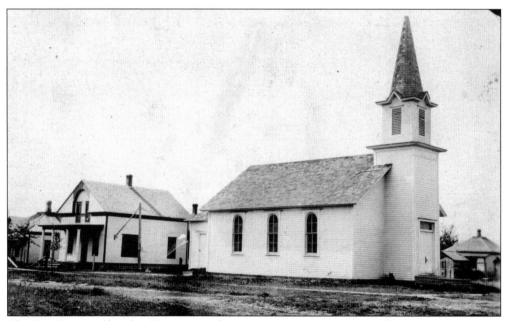

The First Baptist Church of Cairo, seen here in about 1910, was originally established in 1883 at Runnelsburg, northeast of Cairo. Its first services were held in a sod school house. In 1887, the church moved to Cairo, where services were held in the Grand Army hall. By 1901, the congregation had raised enough money to build a church of its own. The Reverend A. H. Shattuck, a carpenter by trade, oversaw the construction.

Six

ORGANIZATIONS

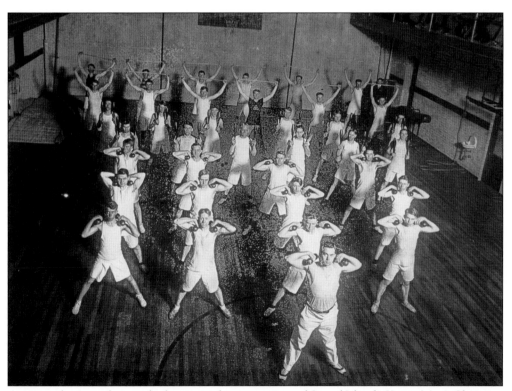

A group of men performs calisthenics in the gymnasium of Grand Island's Young Men's Christian Association in March 1915. The men in front are performing arm curls with dumb-bells. The men in the center are using wooden Indian clubs. The men in back are practicing stretching exercises with wooden sticks. The gymnasium was part of the Grand Island and Railroad YMCA completed in 1914 at the northeast corner of First and North Locust Streets.

The Liederkranz was formed in October 1870 by a group of local German immigrants. The Liederkranz is a German singing and social organization that promotes music appreciation throughout the community. The name *Liederkranz* means "wreath of song" in German. Seen above are members of the Liederkranz choir in the late 1890s. Photographer Julius Leschinsky is the man in the bottom center of the top image, holding the camera's trigger in his hand. The lower photograph, likely taken in the late 1880s, shows the original Liederkranz Hall, built in 1871 at the southwest corner of First and Walnut Streets. The frame building has been decorated for a special occasion, perhaps the second annual "Saengerfest," or festival of male choruses, of the Nebraska Saengerbund, or men's singing club, which was held in Grand Island during the summer of 1889.

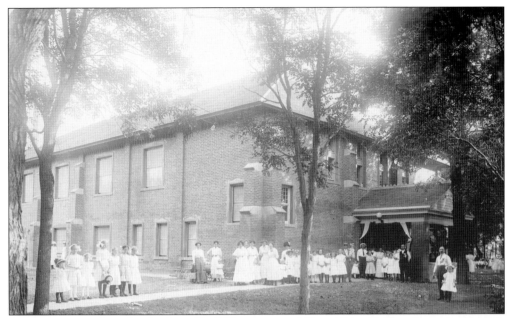

A large group gathers for the June 18, 1911, opening of Grand Island's Platt-Duetsche Verein's new clubhouse. Founded on April 30, 1884, the society was designed for German immigrants and their families to socialize and relax with other immigrants. They originally met in the Liederkranz Hall, Hann's Park, and the Ancient Order of United Workmen building. In 1910, they purchased Ott's Ice House and remodeled it into their clubhouse.

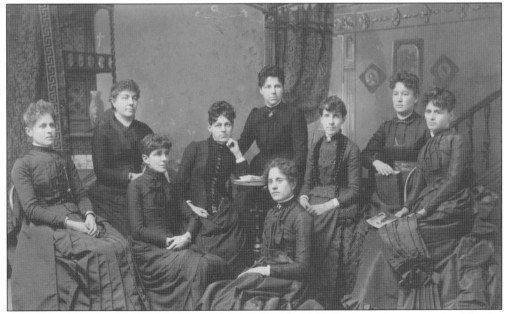

Grand Island's St. Cecilia Society was organized in June 1885 to promote musical culture in the community. The women pictured in this late 1880s photograph are believed to be the society's founding members. From left to right are (first row) Emma Bell, Evelyn Bacon, Marcia Hilliker, Margaret Howard, Eva Barr, and Mary A. Wooley; (second row) Mrs. M. F. Fisher, Clara Robinson, and Ida M. Heffleman.

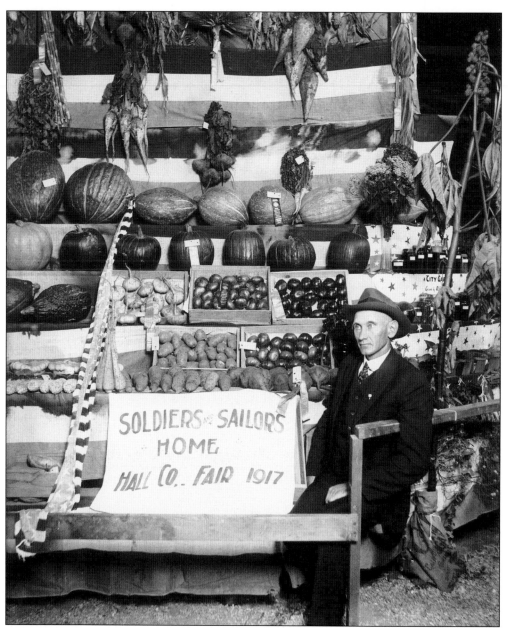

Hall County has a long and interesting agricultural fair history. The Hall County Agricultural Society was originally organized in 1872. In 1874, the Agricultural Society purchased, for $1, a tract of land suitable for use as a fairground. That same year, however, a grasshopper plague devastated Hall County's crops and the fair was cancelled. In 1875, Hall County held its first successful fair. Over the decades, the popularity of the Hall County Fair would rise and fall. It was reorganized and relocated several times. This photograph was taken by Grand Island photographer Julius Leschinsky at the 1917 Central Nebraska Agricultural Society Fair. An unidentified man poses with the award winning produce featured at the Soldiers' and Sailors' Home booth. According to the September 21, 1917, edition of the *Grand Island Independent*, 3,159 people took in the fair in a single day and 1,300 stayed for the fireworks that night.

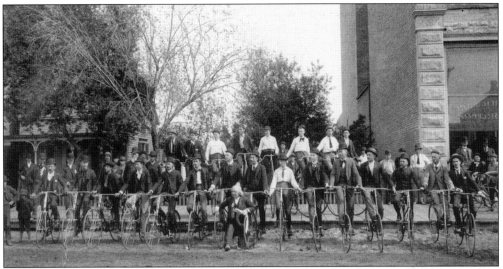

Members of the Grand Island Wheel Club pose with their bicycles in the 200 block of East Third Street in the early 1890s. The eight riders in the back row are mounted on bicycles with high front wheels called "ordinaries" or "penny-farthings." The riders in the front row are on what would be considered the more conventional bicycle today, the "safety" bicycle.

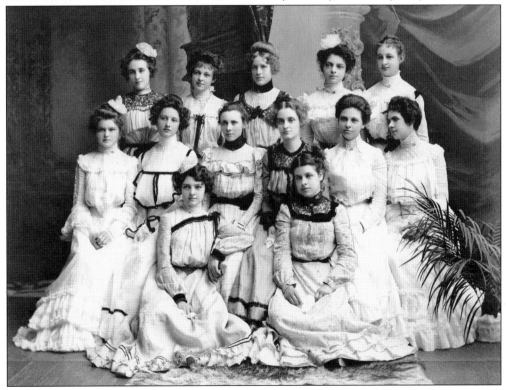

Social clubs during the late 19th and early 20th centuries were an important part of communities. Grand Island photographer Julius Leschinsky photographed the 13 members of the Myosotic Club featured in this photograph on July 2, 1901. Nothing is known about the Myosotic Club, except that their name is derived from the Latin word for the forget-me-not flower.

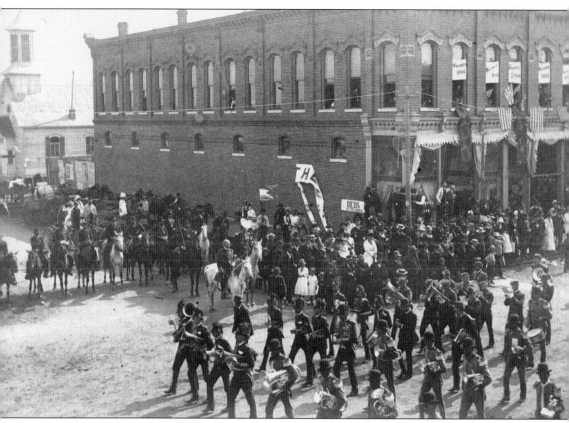

In 1886, members of the Grand Army of the Republic march by the southwest corner of Third and Pine Streets in Grand Island during a reunion parade. The Grand Army of the Republic was a national organization of Civil War veterans who served in the Union Army. Nebraska governor John M. Thayer is seated on the white horse near the center of the photograph. Band members are dressed in military-style uniforms.

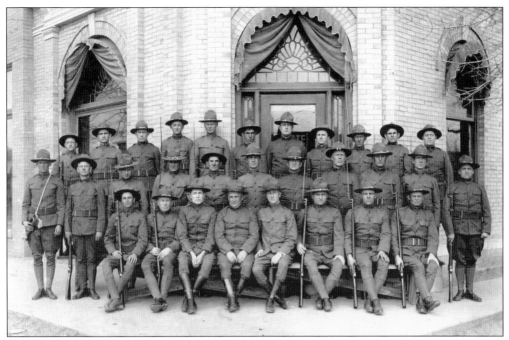

Pictured here in 1918 is the Cairo Home Guard in front of the Farmer's State Bank in Cairo. The men wear World War I–style army uniforms. Several of the men hold rifles with bayonets attached.

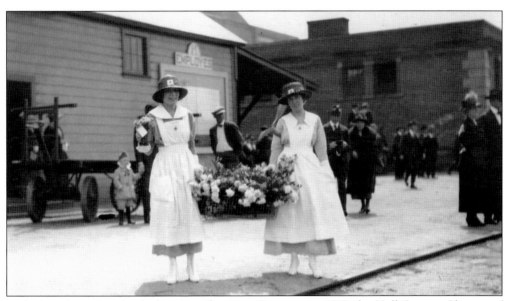

Only four days after the declaration of war on Germany in 1917, the Hall County Chapter of the American Red Cross met for the first time. Red Cross canteen volunteers, like the two unidentified ladies featured in this photograph, fed soldiers traveling both to and from the war. At the Canteen's location in the old Union Pacific depot, 57,890 service men were fed from 1918 to 1919.

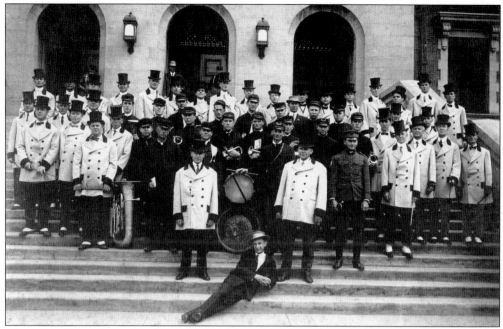

Members of Grand Island's Benevolent and Protective Order of Elks pose on the Hall County courthouse steps in about 1925. Grand Island Elks Lodge No. 604 was chartered on July 12, 1900. Originally meeting at the Grand Army of the Republic hall, the order later dedicated its own brick hall in 1918, which is still standing on the corner of First and Locust Streets.

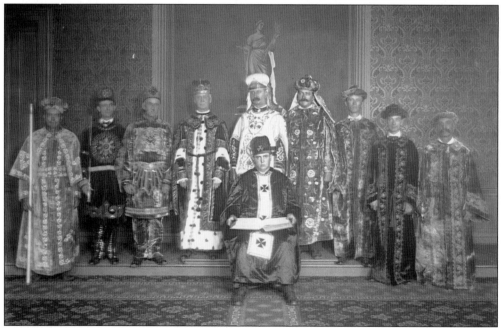

Grand Island photographer Julius Leschinsky took this photograph for the Grand Island Masonic lodge in 1916. The Grand Island Masonic lodge was one of the first to be formed in the state of Nebraska. Organized in October 1870, the fraternal organization steadily grew, spreading to form a lodge at Wood River in September 1891.

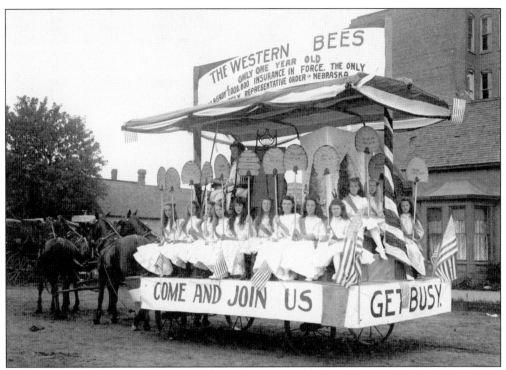

Hall County saw the rise of many insurance-related social organizations in the first quarter of the 20th century. Seen here is a parade float for one such organization, Grand Island's Western Bees. Several young women hold beehive shaped signs in about 1910. Across the top of the float the sign advertises the strength of this organization. Banners along the float's bottom read Come and Join Us, and Get Busy.

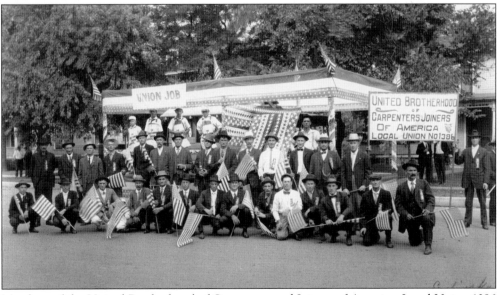

Members of the United Brotherhood of Carpenters and Joiners of America, Local Union 1386 pose with their patriotic Labor Day parade float. This photograph was taken on September 1, 1919. Many of the men hold flags and several have ribbons attached to their shirts and coats.

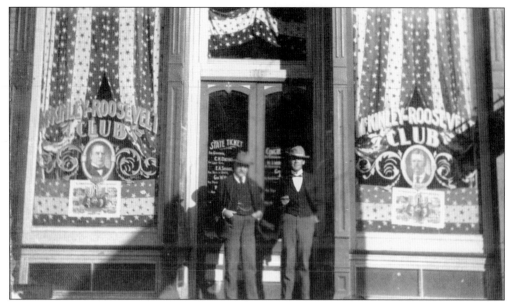

In 1900, Republican nominees William McKinley and Theodore Roosevelt were locked in battle for the presidency against William Jennings Bryan and Adlai E. Stevenson. Grand Island Republicans formed the McKinley-Roosevelt Club to rally local support against the opposing Bryan Club. The patriotically decorated McKinley-Roosevelt Club likely occupied 116 West Third Street. The efforts of the club paid off, barely. McKinley won Grand Island by two votes, 1135 to 1133.

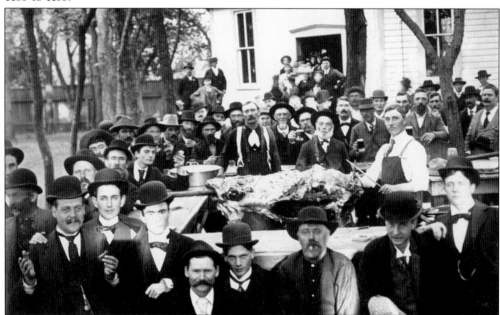

A large group of Grand Island businessmen are gathered at a public barbecue held in 1896 at Martin Schimmer's Sand Krog. Public meetings like this one were the earliest form of Grand Island's Chamber of Commerce. The Sand Krog, a roadhouse-tavern, was located south of Grand Island, directly west of present-day Hall County Park. Note the roast ox being prepared in the center of the group.

Seven

TRANSPORTATION

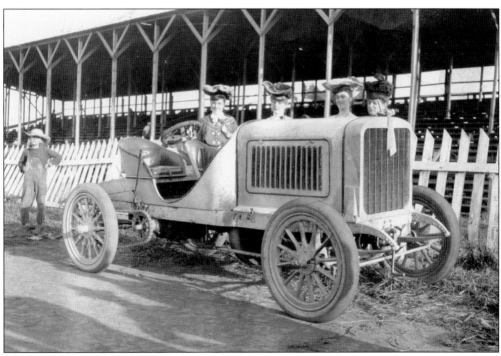

This roadster is much different from modern race cars. Notice the crank start in the front and the chain drive on the driver's side rear. The hood is also unique, hiding what is clearly a large engine. In addition, access to the engine is provided by a center hinge as well as louvered mid-panels. This *c.* 1910 photograph was taken at Grand Island's race track in Delwood Park located in the east end of Hann Park.

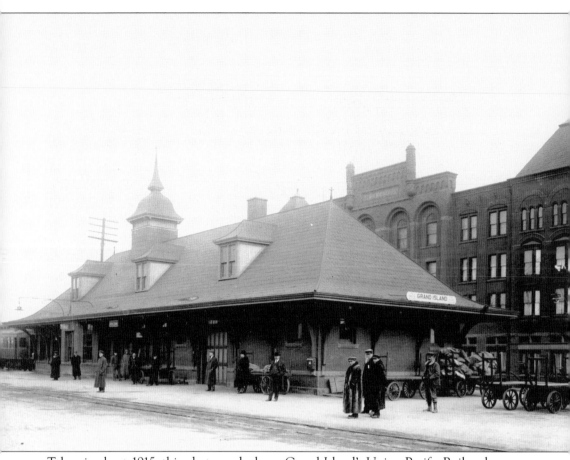

Taken in about 1915, this photograph shows Grand Island's Union Pacific Railroad passenger depot. This frame depot was completed in 1892 on West South Front Street. The 14 male figures on the passenger platform appear to be bundled for winter weather. The four-story brick structure in the background is the Koehler Hotel, completed in 1893. This depot was replaced by an elaborate brick and stone depot in 1918.

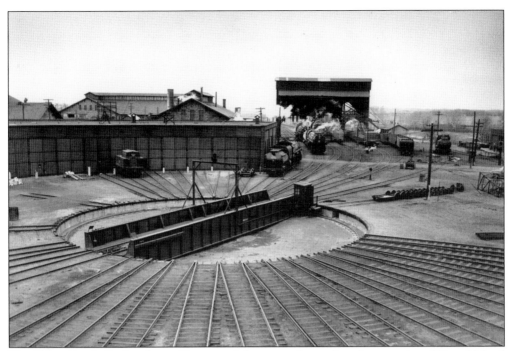

The Union Pacific Railroad roundhouse and shops were located on the east edge of Grand Island between the railroad tracks and Highway 30. The roundhouse, seen above in about 1940, was completed in November 1888 at the cost of $350,000. It originally had stalls for 25 locomotives. The stone building of the shops (seen below with Union Pacific workers in the late 1890s or early 1900s) was known as the machine shop. It was completed in 1881 and is the only original building still standing.

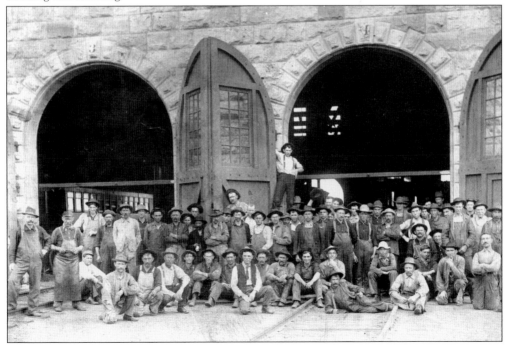

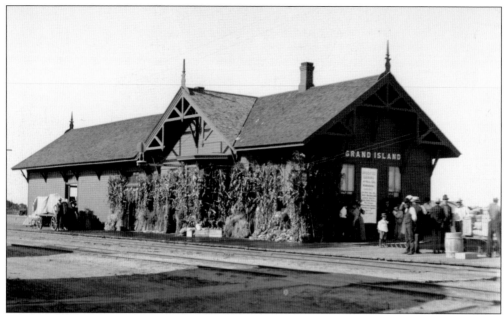

When it arrived in Grand Island in 1884, the Burlington and Missouri River Railroad built the passenger depot seen in this c. 1893 photograph. It sat near Fifth and Plum Streets, south of today's Plum Creek Station. The sign between the windows at the depot's south end refer to "Diversified farming in Hall County, Nebr." Tall stalks of corn lean against the depot's west side.

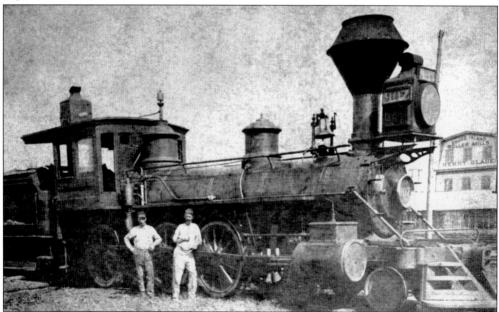

Taken in 1887, this photograph shows two men, the engineer and probably the fireman, posed at the side of a 4-6-0 "10-wheeler" steam locomotive, Union Pacific Railroad Number 907. It is stopped east of the Walnut Street crossing of the Union Pacific tracks in Grand Island. Visible at right is the Henry Glade Roller Mill. The man at left is Charles Milisen Sr., an engineer for the Union Pacific Railroad.

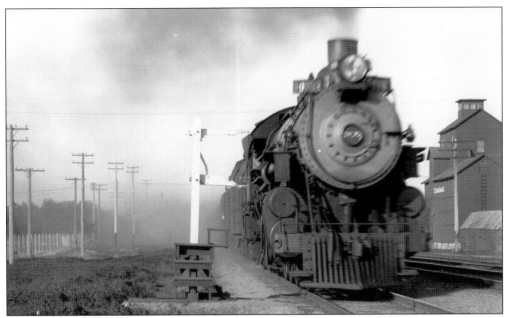

Seen here on May 5, 1916, an engineer prepares to snatch the mail from its hanger as Union Pacific engine 2870 steams by the Wood River station. Struggling to survive, the first town of Wood River, settled in 1868, was relocated a mile and a half east to its present location in order to be closer to the Union Pacific Railroad tracks. In its new location, Wood River quickly became a successful town.

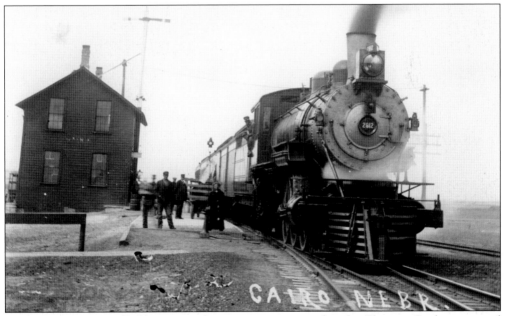

A passenger train, pulled by a steam locomotive, is stopped at the Chicago, Burlington, and Quincy Railroad depot in Cairo in about 1910. A railroad semaphore signal can be seen rising from the roof of the two-story frame depot. The depot sat along the Burlington tracks on the north edge of Cairo. In 1915, it was moved a block west and located on the south side of the tracks.

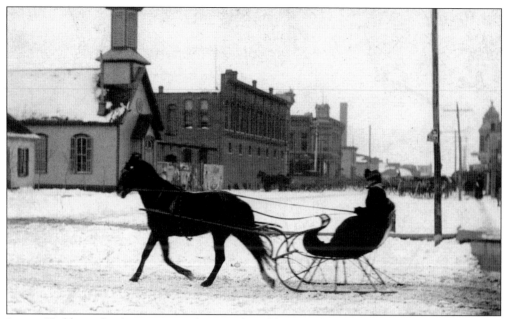

Louise Hedde, wife of newspaper editor Fred Hedde, was photographed in 1887 crossing the snow-covered intersection at Second and Pine Streets in her horse-drawn sleigh, complete with jingle bells. The frame church building at the left on Pine Street was the Methodist Episcopal, also known as the First Methodist Church. North of the church are S. N. Wolbach's Dry Goods Store and the Michelson Building.

Wearing top hats and winter coats, two men ride a mule-drawn road cart down East Third Street. Grand Island photographer Michael Murphy captured this snowy moment in the late 1880s near the front of his photography studio. Small bells are visible on the neck strap of the mule's harness.

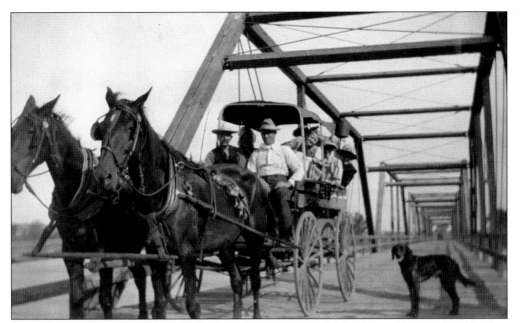

A two-horse team pulls a wagon load of people across a wooden bridge on Nine Bridges Road in southern Hall County in about 1900. As its name implies, a series of nine bridges were needed to cross the Platte River connecting Grand Island and Doniphan.

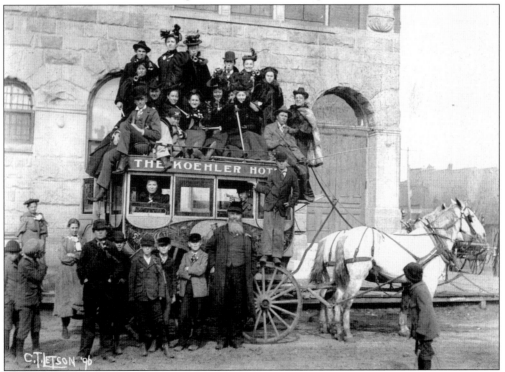

Taken in 1896, a group of well-dressed, young people pose on top of the Koehler Hotel omnibus. Many of the jubilant partygoers hold toy horns. The Koehler Hotel was one of Grand Island's finest hotels, serving the community from 1893 to the 1970s.

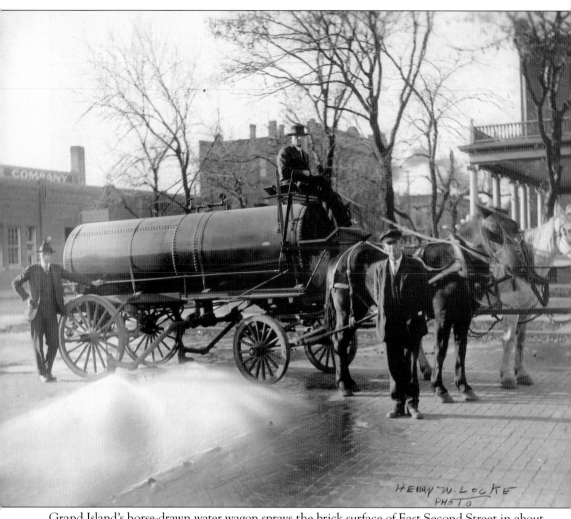

Grand Island's horse-drawn water wagon sprays the brick surface of East Second Street in about 1920. Three unidentified men pose with the wagon at the northeast corner of Second and North Sycamore Streets. Water wagons like this one were used to wash and clean Grand Island's early brick streets, and keep down the blowing dust on unpaved streets.

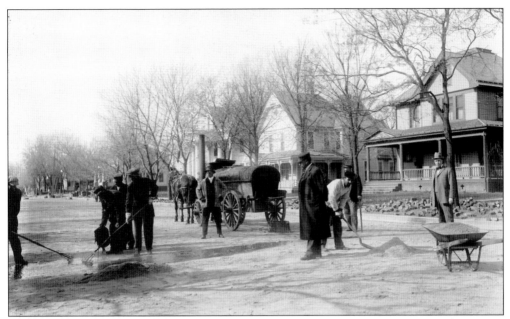

The Western Brick Paving Company's crew prepares the street near the corner of Eddy and Clark Streets in Grand Island during November 1913. The men use sand to level the street before the brick is laid. A horse-drawn water truck is visible at the center. Under the leadership and ingenuity of mayor Henry Schuff, Grand Island received its first paved roads in 1910.

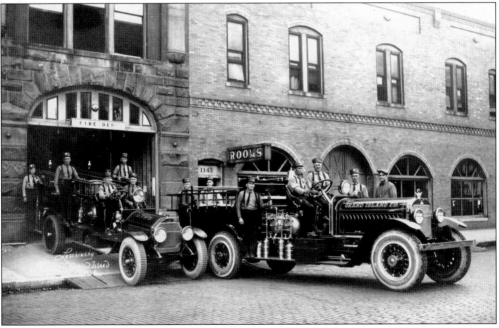

Grand Island firemen pose in front of the City Hall Fire Station in the 200 block of North Pine Street in 1921. The photograph was likely taken in honor of the newly purchased Stutz fire truck (right). The truck at left was purchased in 1913 and was the first motor-driven vehicle used by the department. Both trucks have right-side steering, allowing the driver a better view of fire hydrants.

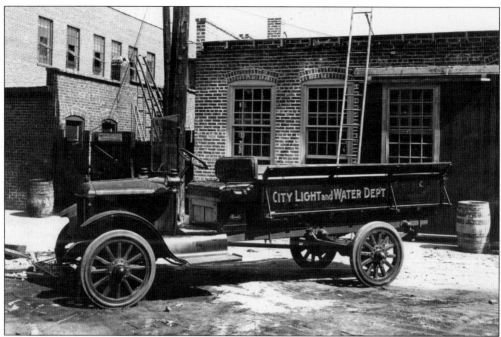

Seen here is the Grand Island City Light and Water Department's truck in about 1915. The truck is parked behind a one-story brick building. Behind the truck, a wooden ladder leads to the building's roof. The truck was made by Republic.

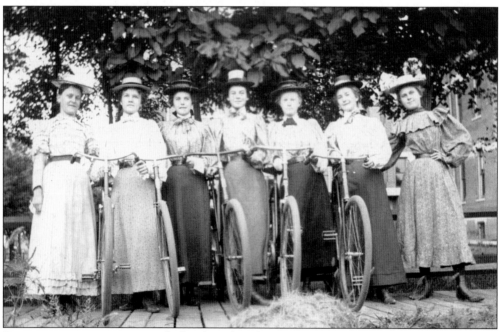

Seven young women pose with five bicycles along a boardwalk in 1897. The women are, from left to right, Tillie Wichbach, Helen Veit, Olga Bernstein, Tillie Spethman, Marie Egge, Alma Bernstein, and Edith Spethman. This image was taken at an unknown location in Grand Island.

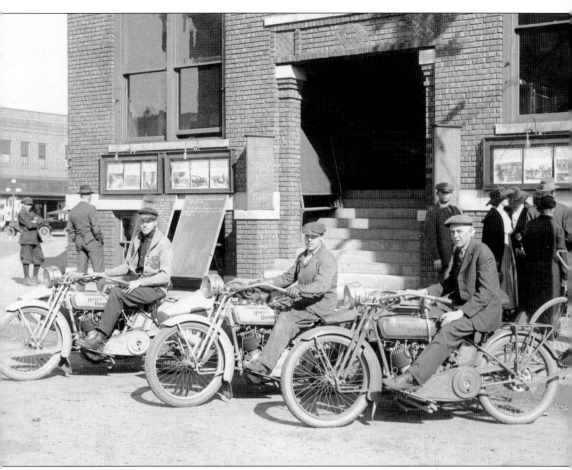

Three unidentified men pose with their Harley-Davidson motorcycles in front of the Grand Island Daily Independent building at 211 North Locust Street in Grand Island. Photographer Henry W. Locke captured this image in about 1915. The man on the far left wears a sweater with the familiar Harley-Davidson bar and shield logo. Several people can be seen behind the riders reading the newspaper's headlines posted on the bulletin boards outside the its offices.

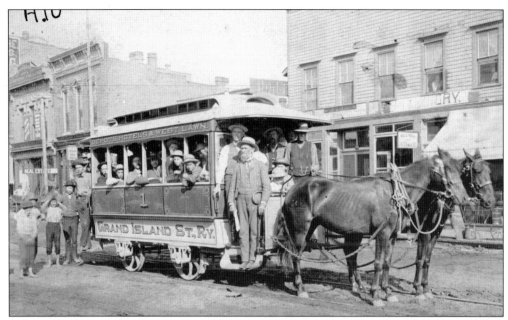

A horse-drawn trolley car of the Grand Island Street Railway Company is stopped in the 200 block of West Third Street in the late 1880s. The street railway operated from 1887 to 1899. It initially served the central business district along Third Street, branching out to the Burlington and Missouri Railroad depot. Later, it expanded north to Grand Island's Soldiers' and Sailors' Home, west to the sugar beet factory, and south to St. Francis Hospital.

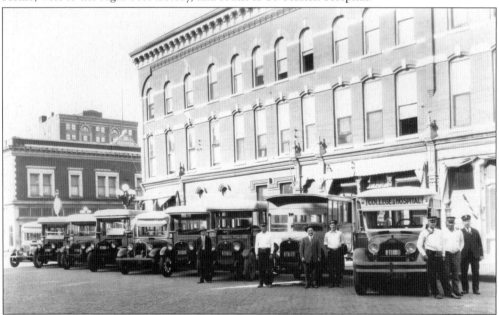

The Grand Island Transit Company's buses are parked in the 100 block of North Pine Streets in front of the Michelson Building in 1926. The Transit Company was established by Greek brothers James, Gus, and George Camaras in 1921. The company's first two buses traveled to the Soldiers' and Sailors' Home and to St. Francis Hospital. Later, their routes covered nearly every part of the city before ceasing operation in 1961.

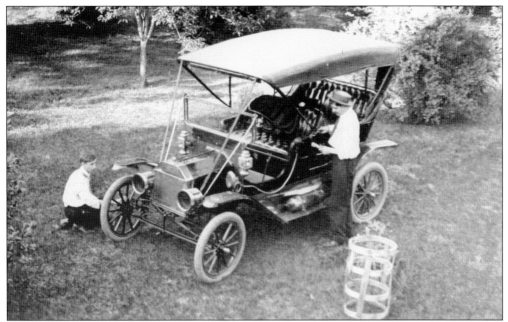

Armand (left) and Oswald (right) Leschinsky, sons of photographer Julius Leschinsky, appear to be working on the family's Model-T Ford touring car in about 1911. This is believed to be the first car the Leschinskys owned. The photograph was taken in the backyard of the Leschinsky home at 518 West Koenig Street in Grand Island.

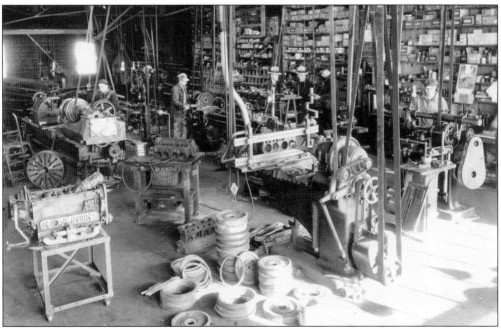

With the emergence of the automobile in Hall County, mechanical shops began to replace blacksmiths, livery stables, and saddle shops. Seen here is one such automotive shop that catered to nearly every aspect of the fancy new invention. Everything from cylinder wall boring to engine repair could be done in this shop. This photograph was taken in about 1915.

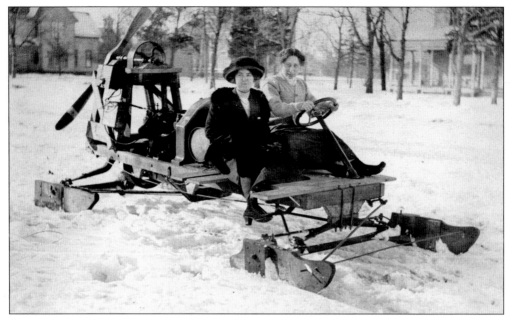

Eva (Brass) Vieregg steers a motorized, air-powered sled. Likely built during cold, snowy Grand Island nights in about 1910, this homemade invention is a testimony to local ingenuity and creativity. An airplane propeller powered by what appears to be an automobile engine propels the lightweight metal and wooden skid across ice and through snow.

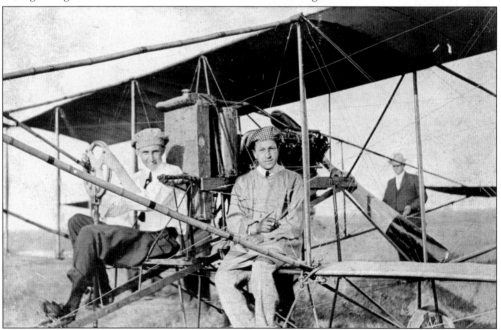

In 1911, 19-year-old pilot Cromwell Dixon (left) arrived in the first airplane to land and take off in Grand Island. It was a simple biplane with a pusher engine and tricycle landing gear. It was built and owned by the Curtiss Aviation Company. Dixon flew the airplane in Grand Island on August 30, 31, and September 1. The Grand Island Retail Merchants Association sponsored the flying exhibition.

Eight

ENTERTAINMENT AND SPORTS

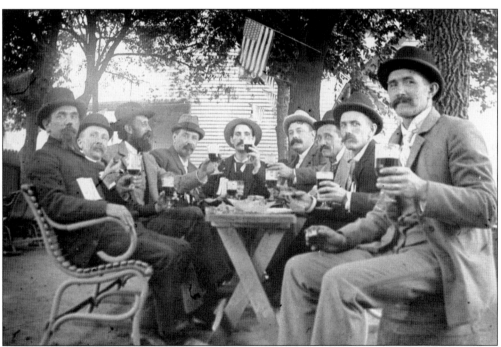

Taken in the 1890s, this photograph shows nine men, all holding glasses of dark beer, posed around a table in an outdoor setting. American flags are visible in the trees, suggesting that it might have been a holiday, such as the Fourth of July. This photograph is believed to have been taken at Grand Island's Hann Park. Developed by early settler John Hann, the park was a 20-acre site that stretched east from South Locust Street toward South Oak Street, roughly between Charles Street on the south and Koenig Street on the north.

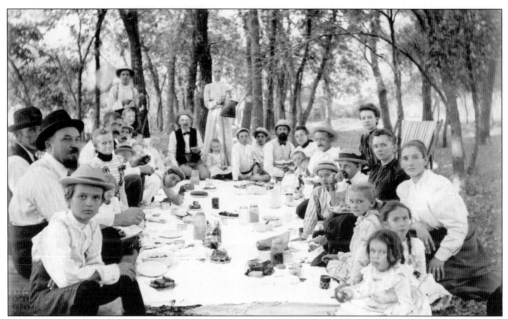

What better way to spend a warm summer afternoon than enjoying good food and fresh air with friends and family? That is what this large group of Grand Island residents did about 1910. They look ready to enjoy all the goodies spread before them on their picnic blanket. Several members of the group are seated on wooden crates. One lucky woman is seated in a striped canvas lawn chair at the far right of the photograph.

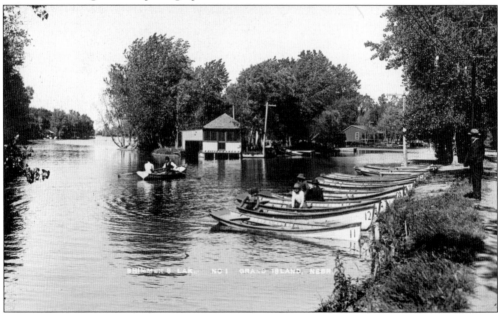

Small wooden boats line the shore of Schimmer's Lake in about 1915. Schimmer's Lake was established in 1898 by Martin Schimmer for the production of ice. The lake was located at the site of today's Hall County Park, south of Grand Island. It became a popular resort for central Nebraskans. Water for the man-made lake was supplied by damming the Wood River. After the dam broke in 1942, the lake dried up.

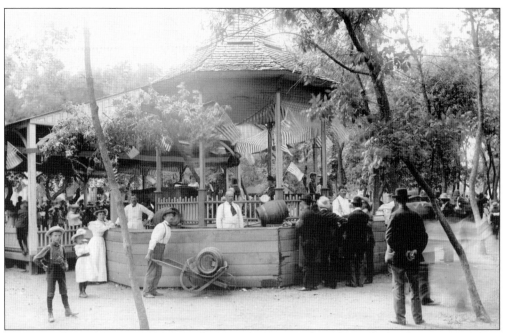

American flags and patriotic bunting decorate the beer garden of Grand Island's Hann Park for a late-1890s Fourth of July celebration. The 20.5 acre park stretched east from today's South Locust Street to about South Oak Street and south from about Koenig Street to Charles Street.

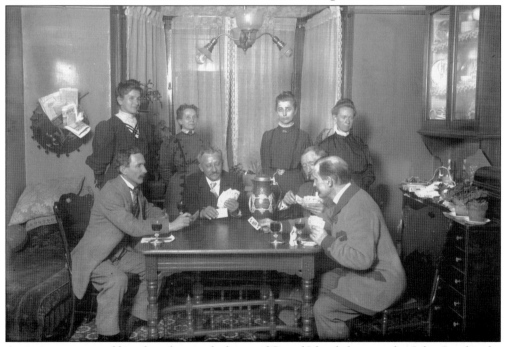

An intimate group of friends gathers in the home of Grand Island photographer Julius Leschinsky (right) to play a friendly game of cards and share a glass of wine in about 1910. Leschinsky's wife Minnie is the third woman from the left. Featured prominently in the center of the table is a large ceramic wine pitcher with a silver lid.

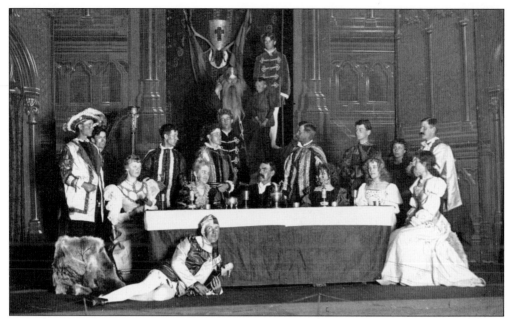

A troupe of unidentified costumed performers poses on a stage. Obscured by the elaborate sets, the exact location of this play is unknown. However, since this image was once part of an album that belonged to local amateur photographer Max Egge, it was likely in Grand Island during the late 1890s. From the quality of costumes and sets, it is possible that this was a professional traveling troupe of actors.

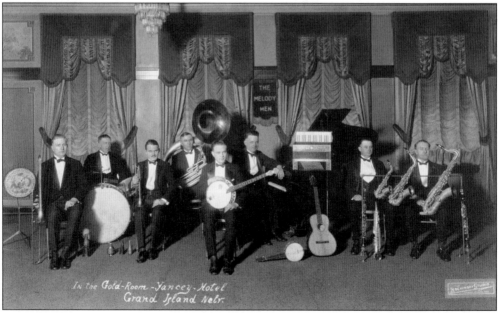

The Melody Men are seen here seated with their instruments in the Gold Room of the Yancey Hotel in about 1925. The Melody Men were led by Herman "Ham" Krall, seated at the piano. Krall's big band stylings made him a popular musician during the 1920s, 1930s, and 1940s. The Yancey Hotel, completed in 1923, was Grand Island's premier hotel. The Gold Room was the hotel's largest banquet room.

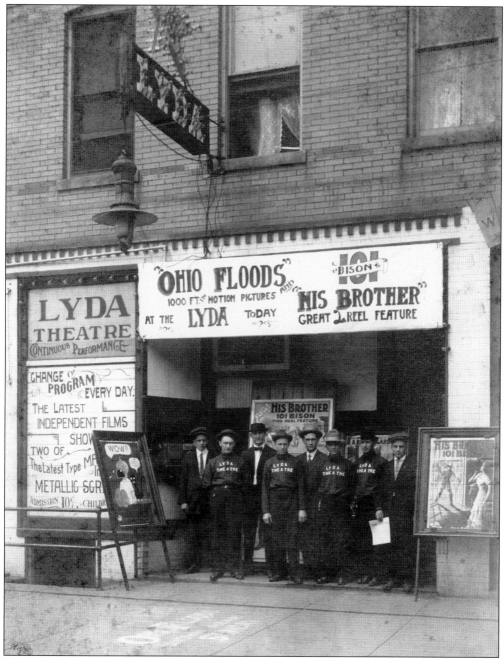

The Lyda Theatre brought the magic of motion pictures to Grand Island from 1912 to 1931. It was located at 306 West Third Street, the site of today's Grand Theater. Tyne Hayman, third man from the left, was the man who ran the show. He managed the Lyda as well as two other movie theaters, the Majestic and the Empress. This photograph was taken in 1913.

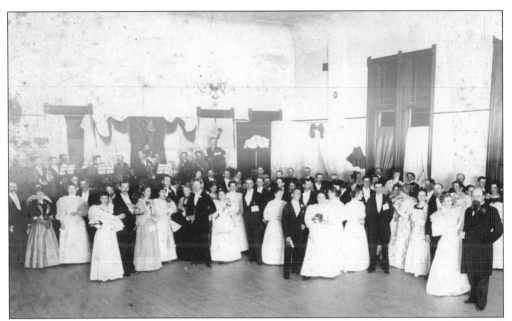

The leap year of 1892 was celebrated in Grand Island in a most splendid fashion. A formal ball was held in the second floor ballroom of the Ancient Order of United Workman hall on Grand Island's Second Street. Music was provided by the Herman A. Bartling Orchestra, visible in the far left of this photograph.

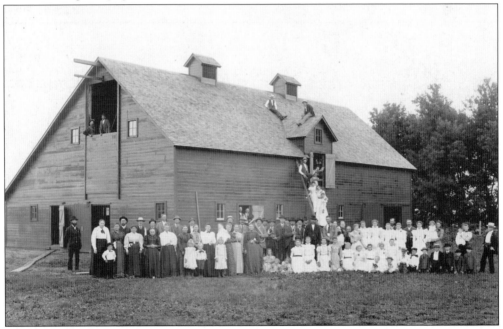

In 1900, F. F. Suehlsen built a new barn. To celebrate, he threw a party. Men, women, and children dressed in their country best gathered at the Suehlsen farm in Lake Township to enjoy a night of food, friends, and fun. Over the years, Suehlsen held many more barn dances. The country celebrations became so popular even the "city folks" from Grand Island would flock to the Suehlsen farm.

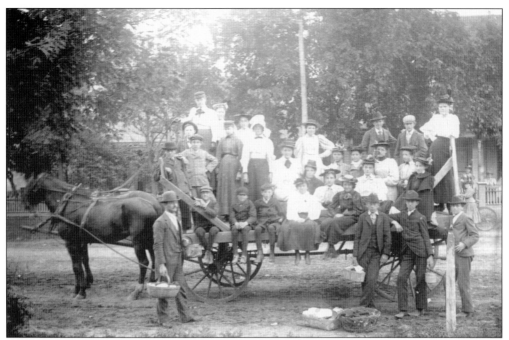

Hayrack rides have long been a favorite activity of Hall County residents. Seen here is a group of about 30 Grand Island residents ready for a picnic in about 1910. Several wicker baskets are visible in the foreground.

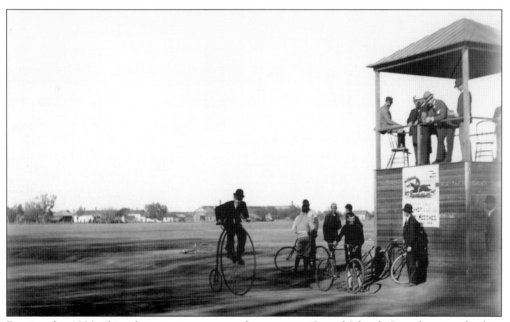

During the 1890s, bicycle racing was a popular sport in Grand Island. Seen here in the late 1890s, a man riding an old-fashion penny-farthing bicycle appears to be challenging the speedier new safety bicycles. The men with the safety bicycles do not appear to be taking his challenge seriously. The race track was located at Grand Island's Puckwana Park, located on South Locust Street.

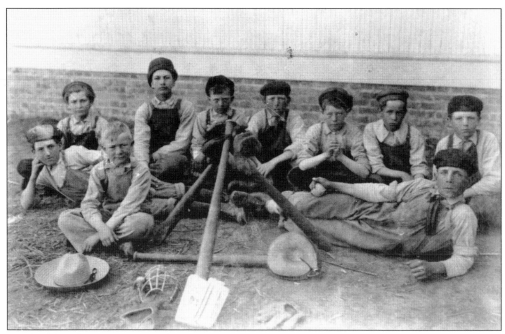

Baseball has been an important part of every community in Hall County since the earliest forms of the sport. Many people have enjoyed the organized leagues throughout the county as a social activity that has developed local pride. Above is a group of young Cairo boys early in their baseball careers, while below is a more organized Doniphan team.

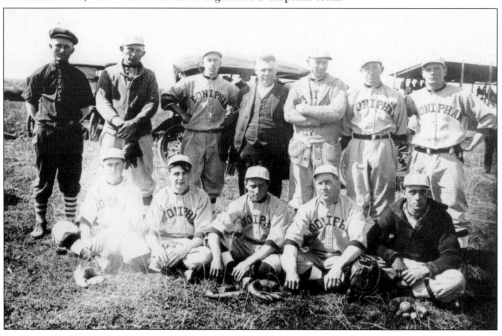

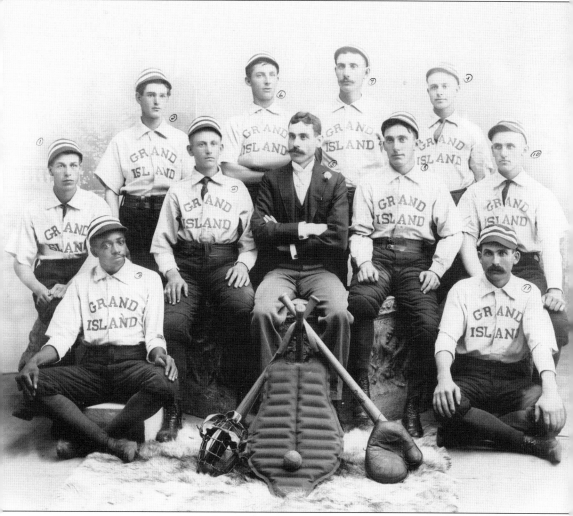

The 1895–1896 Grand Island Colts baseball team posed for a photograph. From left to right are (first row) ? Booker and Dan Linahan; (second row) Herb Crossman, Phil Glade, Jim Rourke, Charles Rollins, and Fred Glade; (third row) ? Richardson, Joe Schweiger, William Ryder, and Dick Buenz. Fred Glade went on to pitch in the major leagues with the St. Louis Browns from 1903 to 1907 and the New York Highlanders in 1908.

The German word *turner* relates to gymnastic skills and was a popular physical culture activity around 1900. In Grand Island, Oscar R. Niemann (above, bearded man at far left) taught turner classes from the late 1890s through the 1920s for both men and women. Above, members of Oscar R. Niemann's turner classes pose on the lawn of William Stolley's home in 1895. The five dramatically posed young women, below, were also students of Niemann. Niemann's turner classes included fencing and calisthenics. Calisthenics were preformed with various types of equipment, such as the Indian clubs and small dumbbells that are scattered on the floor of the bottom photograph.

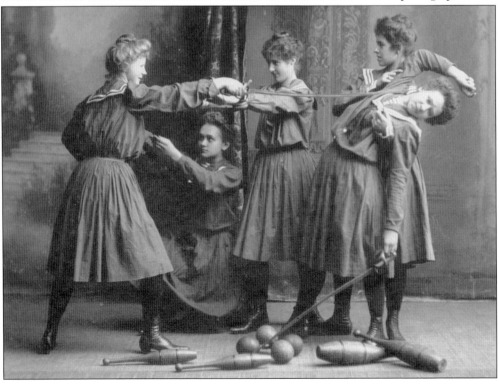

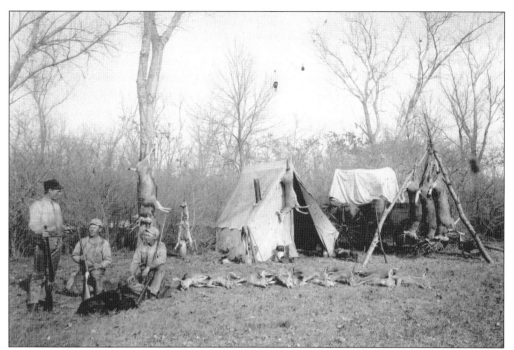

Three men pose with the results of their hunting trip in the fall of 1889. Seen at their camp at the head of Big Creek on the Middle Loup River, the men are, from left to right, Emil G. Stolley, J. M. Hansen, and Richard Stolley. Emil and Richard were sons of Hall County early settler William Stolley.

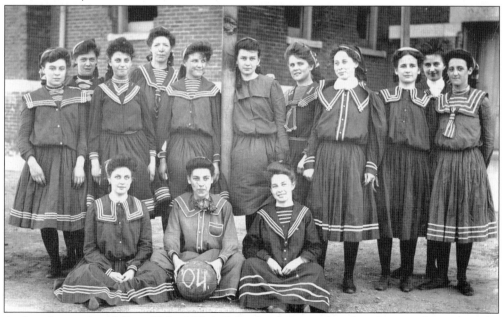

At first glance, the 14 Grand Island High School girls featured in this photograph appear to be more appropriately dressed to sing in a choir than play basketball. However, their knee-length, long-sleeved cotton dresses and wool stockings were considered proper athletic attire for young ladies in 1904.

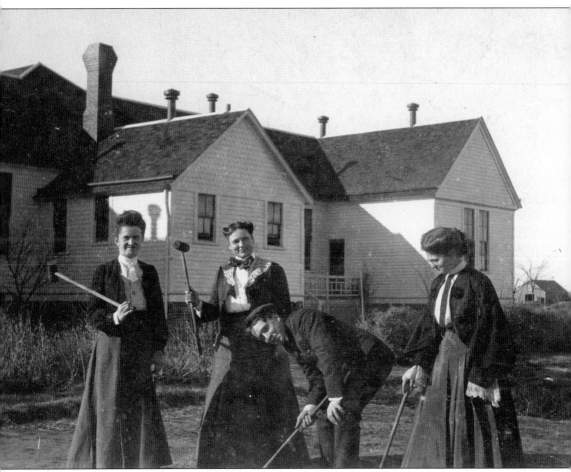

Seen here, Leonard Barnebey lines up a shot in front of the old Cairo School with his three lady friends in about 1905. Croquet gained popularity in America during the 1860s and 1870s. Croquet was even played at the 1900 Olympics; however, by that time, the up-and-coming sport of tennis had surpassed croquet in popularity.

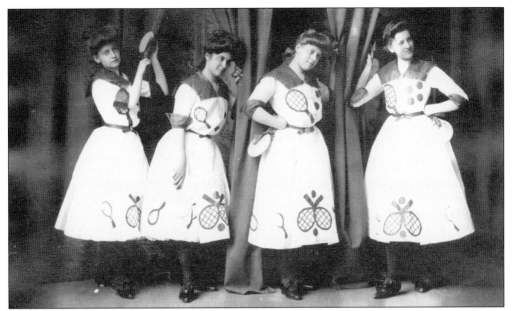

Grand Island photographer Julius Leschinsky photographed these four unidentified ping-pong enthusiasts in his studio on March 11, 1903. Derived from English lawn tennis, table tennis, or ping-pong, gained popularity in the United States in the early 20th century. These young women obviously took the game very seriously. In addition to the ping-pong appliqués on their dresses, they sport paddle-shaped headpieces in their hair.

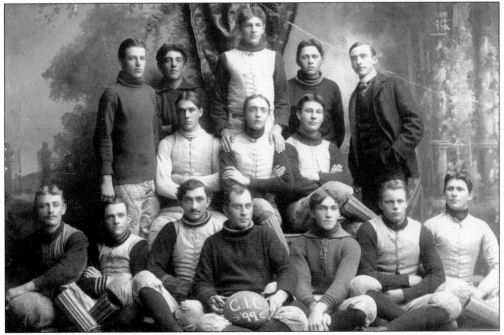

This rough-and-tumble group of young men is the 1899 Grand Island Baptist College football team. Padded, laced-up cotton shirts, quilted pants, and shin guards were these iron men's only protection from the other team. Stocking caps stuffed with rags acted as helmets. Alton Robbins, seated in the center of the front row, holds a "fat" football.

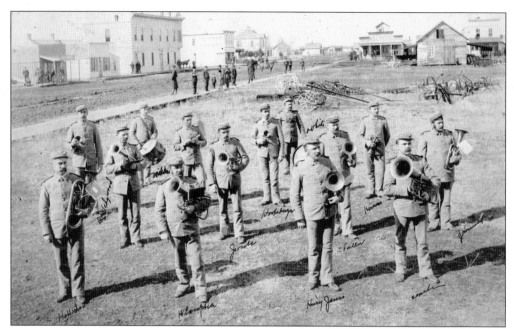

Many communities, large and small, had local bands that played at parades and social functions. Seen here is the Wood River Band posing in a field located near the city's business district in the late 1880s. First row euphonium player, Fred M. Hollister (far left), was also the owner of the general store in the distance.

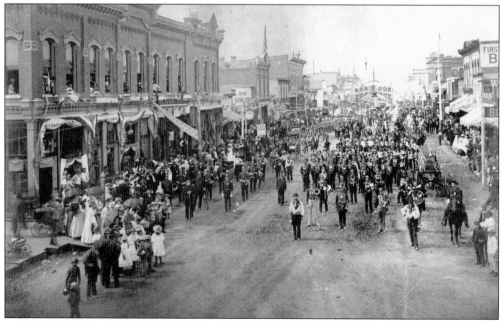

Grand Island's fire department, dressed in their best uniforms, led this patriotic parade on Third Street. At right, the fire department's marching band stands at attention holding their instruments. They are stopped at the intersection of Third and Pine Streets in front of the Wolbach Building (left). This photograph was taken by Grand Island photographer Michael Murphy between 1884 and 1886. Many of the buildings are decorated with patriotic bunting.

Nine

PEOPLE

Julius Leschinsky poses with a few of his many awards and medals in about 1915. Born in Prussia, Leschinsky followed the American dream to Grand Island, achieving the ultimate goal of owning a successful, thriving business. His business grew from a portable photographer's wagon to one of central Nebraska's premier studios. His success led him to become one of the organizers of the Nebraska Photographers Association, as well as its president for three terms. Many of the images in this book come from his impressive body of work.

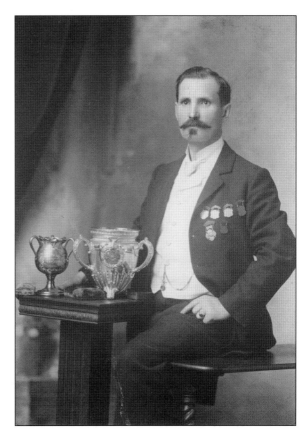

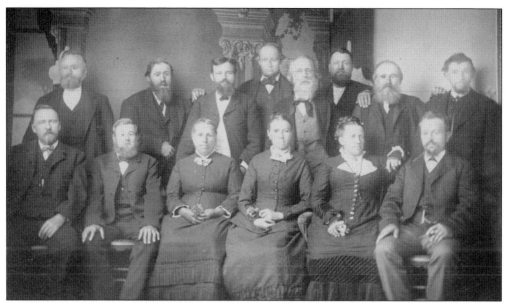

In 1857, thirty-seven men and women ventured from Davenport, Iowa, across the plains to build a town along Nebraska's Platte River. Seen here are the settlers still living in Hall County during the 1882 Quarter Centennial Celebration. Seen here, from left to right, are (first row) William Hagge, Joachim Doll, Catherine Doll, Anna (Stehr) Thomssen, Margaret Joehnck, and Henry Joehnck; (second row) Peter Stuhr, Christian Menck, Herman Vasold, Marx Stelk, Fred Hedde, Detlef Sass, Henry Schoel, and Cay Ewoldt.

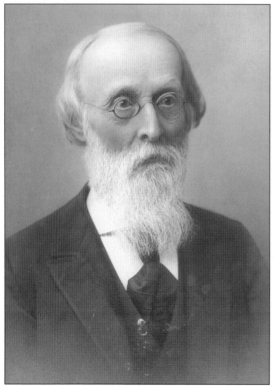

Working as a journalist in Schleswig-Holstein, Frederich Hedde found the restrictions placed on publications by Danish authorities impossible for him to express his principles. Seeking greater freedom, Hedde immigrated to America in 1854. In 1857, he joined a settlement party headed to what would become Hall County, quickly establishing himself as a leader. A successful businessman, Hedde purchased Grand Island's leading newspaper, the *Grand Island Daily Independent*, in 1884.

Strong-willed individualist Wilhelm Stolley (center) was one of Hall County's more prominent early settlers. His drive for success made him an early pillar of the Grand Island community. He helped established Hall County School District Number 1, obtained free transportation of goods to Nebraska, and cultivated his farm through the introduction of non-native trees and birds to the plains. Seen here, Stolley and his wife pose with their children in about 1884.

On September 10, 1864, George Martin and his sons, Henry Nathaniel "Nat" and Robert O., found themselves under attack by Sioux scouts. The Martin brothers attempted to flee together on their pony. A single arrow pierced their shoulders, pinning the boys together. Believed to be dead by both their attackers and their parents, the boys remarkably survived to tell their tale. Seen here, Nat holds the infamous arrow.

While teaching in North Platte, Nebraska, Maggie (Guerin) Mobley began publishing the *Platte Valley Independent* in 1869. In 1870, Maggie and her husband Seth moved the newspaper to Grand Island. The newspaper and its editors quickly earned a reputation for outspoken Republicanism. J. I. Wylie, the editor of a rival newspaper, printed some unflattering things about Maggie. She took offense, and as the story goes, attempted to assault Wylie with a cowhide whip in public.

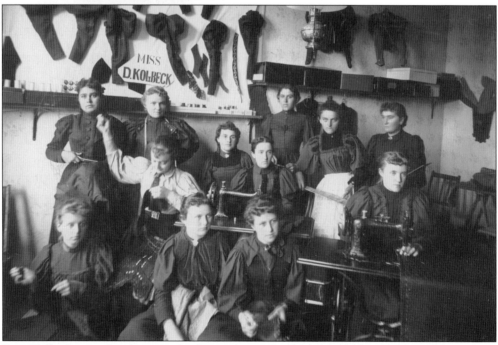

Dora Kolbeck owned and operated a dressmaking school in Grand Island for 14 years, teaching over 600 women. Kolbeck was also an inventor. On August 14, 1906, she received a patent on a plaiting machine that saved dressmakers a great deal of labor in creating pleats. During the 1918 influenza outbreak, Kolbeck helped run the emergency hospital set up to isolate and care for those infected.

Popcorn was always fresh and hot when it came from "Popcorn" Pete. Pete Panos, a Greek immigrant, operated his popcorn cart on the northeast corner of Third and Locust Streets before opening Coney Island Café in 1923 with his brother George Panos and a fellow Greek immigrant Paul Jamison. Although this photograph was taken in the early 1920s, Popcorn Pete was operating his pushcart as early as 1917.

An auctioneer by trade, James "Jimmy" Dunkel helped modernize the Hall County Sheriff's department. Dunkel was elected sheriff in 1905, 1907, 1909, and 1911. He was well liked and respected by fellow law officers, becoming president of the Nebraska State Sheriffs Association and vice president of the national association. During his term as Hall County sheriff, Dunkel instituted the use of telephones, automobiles, and even dogs to help with police work.

Henry Fonda was born in Grand Island on the morning of May 16, 1905, in a quaint, little cottage at 622 West Division Street. Nine months after Henry's birth, the family moved to Omaha. During his lifetime in movies and theater, Henry Fonda won a Lifetime Achievement Award from the American Film Institute in 1978 and an Academy Award for his performance in *On Golden Pond*.

German-born Henry Glade, seen here with his youngest son Arthur, learned the flour milling trade in Iowa before coming to Nebraska in 1878. In 1884, Glade purchased the Grand Island State Central Flour Milling Company and erected a new roller mill near the Union Pacific tracks. By incorporating with other mills, the Glade family business evolved into Nebraska Consolidated Mills in 1920. The corporate name was changed to ConAgra, Inc., in 1971.

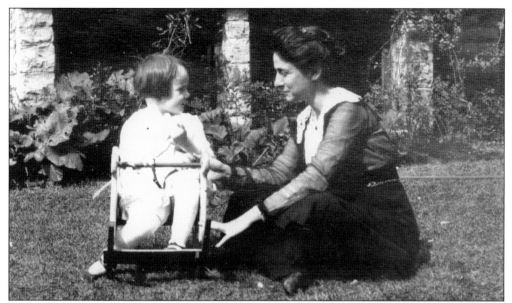

Grace Abbott, seen here with her niece Charlotte, gained international fame as a social worker and reformer. She became known as the "foster mother to the nation's 43 million children." In 1917, she was appointed the director of the Child Labor Division of the U.S. Children's Bureau and the bureau's chief in 1921. While at the bureau, she administered the first child labor law and the Maternity and Infancy Act.

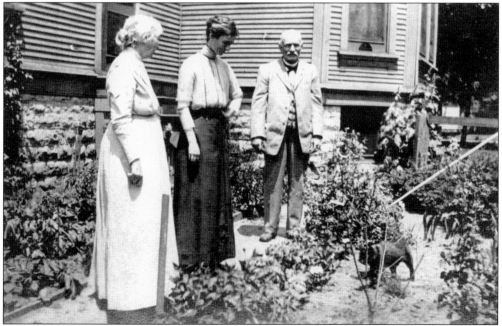

Edith Abbott, at center with her parents in the garden of their Grand Island home, became the first female dean of an American graduate school in 1924. She served as the dean of social service for the University of Chicago from 1924 to 1942. During her successful career, she authored many books including *Women in Industry, Report on Crime and the Foreign Born,* and *Social Welfare and Professional Education.*

Having enlisted without the consent of his master, Anthony Young was able to reach the rank of sergeant in the Union Army, serving in Company C of the 108th Regiment of the U.S. Colored Infantry. After the war, Anthony and wife Harriet homesteaded northeast of Cairo (as did his brother Cpl. Robert Young). After Harriet's death, Anthony married her widowed sister Margaret Colwell, seen here. Together, they raised a family.

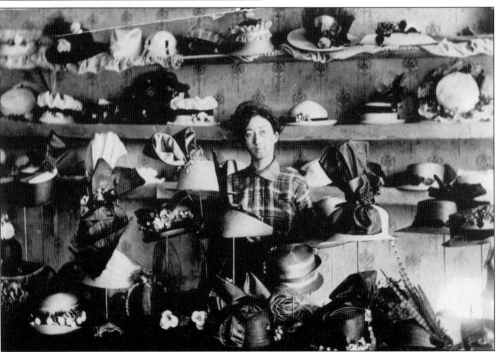

From 1914 to 1934, Cairo's fashionable women could be seen wearing stylish hats from Nettie Boyd's Millinery Shop. According to a 1920 advertisement in the Cairo newspaper, she also offered the latest in hat fashions from market: "Feather hats, Panne and lion silk velvet, velvet and duvetyn combined sailor and veils."

Ten

LIGHTER SIDE

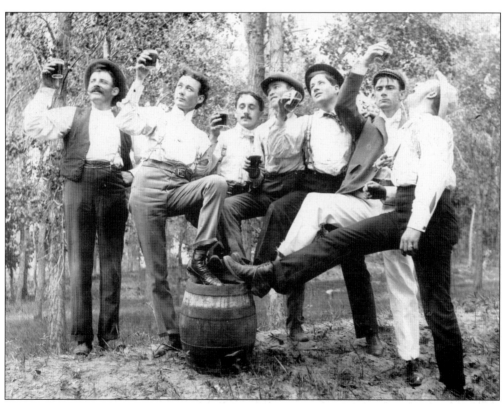

Seven young men toast the good life in 1890s Grand Island. This moment of levity was captured at Hann Park, a 20.5-acre park stretching east from today's South Locust Street to about South Oak Street. The park was a popular gathering place. It featured an outdoor dance pavilion, bandstand, snack bar, and beer garden.

David Kaufmann opened his first variety store in 1906 at 218 West Third Street. In 1924, Kaufmann opened a new store at 308–312 West Third Street. Kaufmann's offered its customers just about everything they needed, from china to pet food. His well-stocked candy counter always included a plethora of sweet treats.

To celebrate the new century, Grand Island threw a huge party. One of the celebration's highlights was the floral parade held on August 30, 1900. Participants worked nearly two weeks decorating carriages, bicycles, and saddles in a variety of flowers. Themes ranged from red poppies to yellow daisies. Minna (Stolley) Roeser's vehicle decorated with pink chrysanthemums won first prize. The carriage in this photograph is decked out in calla lilies.

Two unidentified poker players pose for Grand Island photographer Julius Leschinsky in his studio in about 1915. The man seated on the right, looking rather smug, shows the camera his winning hand of a Royal Flush. The man on the left does not seem to be bothered by his defeat. At their feet is an empty bottle of root beer, bottled by Grand Island soda manufacturer Henry Vieregg.

This magical garden is the backyard of Grand Island photographer Julius Leschinsky at his home located at 518 West Koenig Street. The lovely Vivian Donner poses as the garden fairy. This photograph was taken on May 23, 1911. Note the many different types of flowers and foliage in the Leschinsky garden. A few that are identifiable are hydrangea, white and red geraniums, allyssum, and phlox.

Built to promote the growing sugar beet industry in Grand Island, the Sugar Palace stood on the 300 block of East North Front Street from 1890 to 1894. Modeled after the Corn Palaces in Iowa and South Dakota, the Sugar Palace was 200 square feet and 100 feet high. Its exterior was covered with sugar barrels. Inside, the palace housed elaborate exhibits, such as the one seen in this photograph.

The 1889 Hall County Agricultural Society Fair was blessed with one of the greatest expressions of Nebraskan pride. Constructed almost entirely of popcorn, H. B. Kerr constructed what he called the "Grand Island Corn Palace." The Grand Island grocery store operator stole much of the fair's attention with his miniature house of corn. Like the sign above the Corn Palace says, in Nebraska, Corn is King.

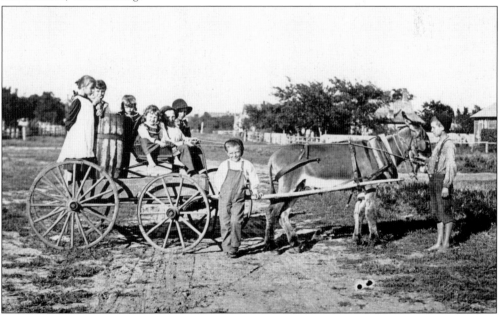

A group of unidentified children pose with a small donkey cart. The young boy at the far right is barefoot. This photograph was likely taken in about 1910.

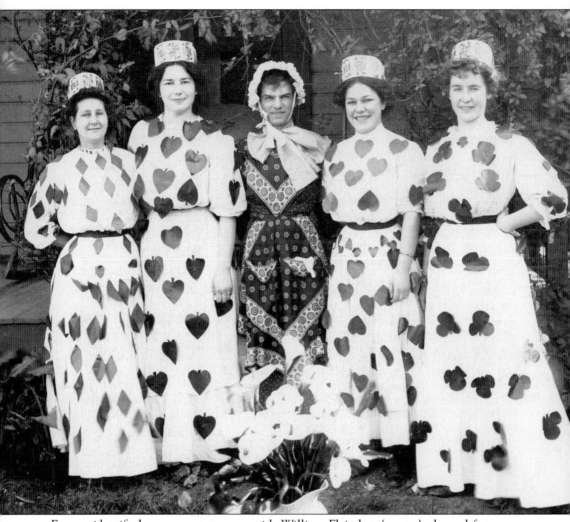

Four unidentified young women pose with William Fleischer (center), dressed for a costume party in about 1915. The ladies have pinned hearts, diamonds, clubs, and spades to their white dresses to represent the four suits in playing cards. Fleischer, sporting a lady's bonnet and apron, apparently plays the joker.

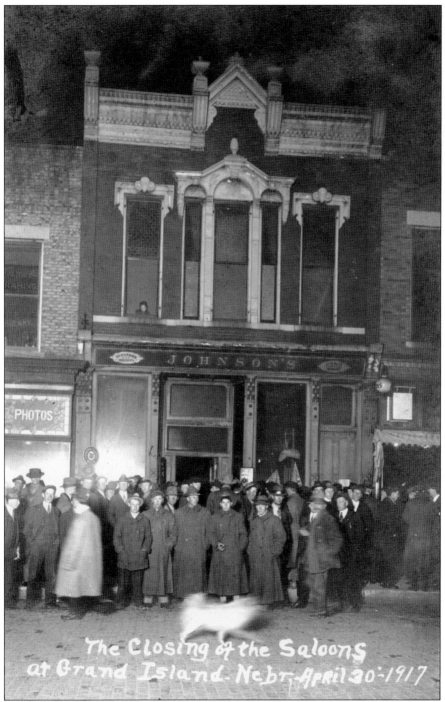

The Closing of the Saloons at Grand Island - Nebr. April 30°-1917

In 1916, Nebraska voters asked for and received a prohibition amendment to the Nebraska State Constitution. Prohibition outlawed the sale and production of alcoholic beverages. Enforcement of the prohibition began in Nebraska on May 1, 1917. Grand Island photographer Julius Leschinsky captured this large crowd of unhappy looking men gathered outside of Johnson's Saloon on April 30, 1917, the night before all saloons in Nebraska officially closed.

Six men pose outside the Harrison Cabin on Schimmer's Lake. The cabin, nicknamed the "Country Club," was built in the spring of 1906 by brothers Fred and Guy Harrison, Oscar Hart, and brothers Robert and Charles McAllister. Originally created in 1898 as an ice lake, Schimmer's Lake became a popular local summer retreat. At the lake, many Grand Island residents enjoyed boating, swimming, and all kinds of summer mischief.

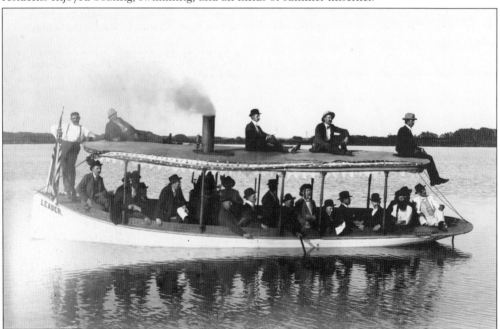

A large group of men take a spin on the little steam boat dubbed *Leader* on the Fourth of July, 1898. Their boat ride took place on Martin Schimmer's lake south of Grand Island. Schimmer originally dug the lake to produce ice. It was completed in May 1898 and quickly became a popular summer gathering place for picnics, swimming, and boating.

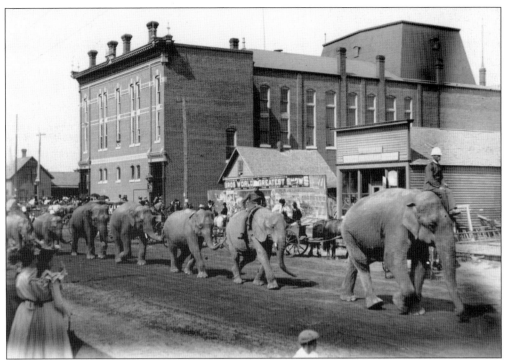

On August 27, 1897, onlookers lined Second Street to watch this thunderous herd of pachyderms parade past the Bartenbach Opera House. When the Ringling Brothers came to town, huge crowds turned out to see the amazing attractions. From camels and hippopotamuses, to steam-powered calliopes, traveling circuses allowed residents of Grand Island to experience the exotic without leaving home.

United States mail carrier Jonas D. Kleinkauf is seen here loaded down with parcels and letters. This photograph was taken in the Leschinsky Studios on January 9, 1903. Kleinkauf began delivering mail in Grand Island in the late 1890s. Free mail delivery began in Grand Island in October 1887, and 29,904 pieces of mail were delivered in the first month.

Five unidentified Halloween cuties smile and point to a Jack-O-Lantern. Grand Island photographer Julius Leschinsky captured this adorable image in about 1905.

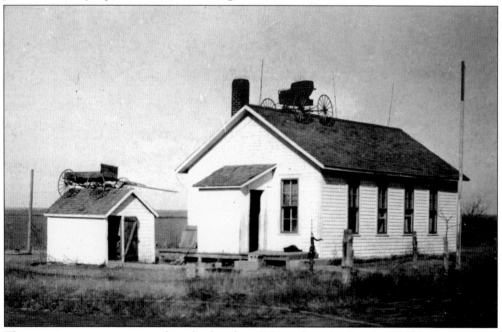

This strange scene was captured on the first day of November, the day after Halloween, in about 1920. Bluff Center's mischief makers must have worked all night to put Minnie Kruse's buggy on the roof of the rural schoolhouse. For an added measure of mischief, they also raised Barns Rollifson's farm wagon to the roof of the school's coal shed.

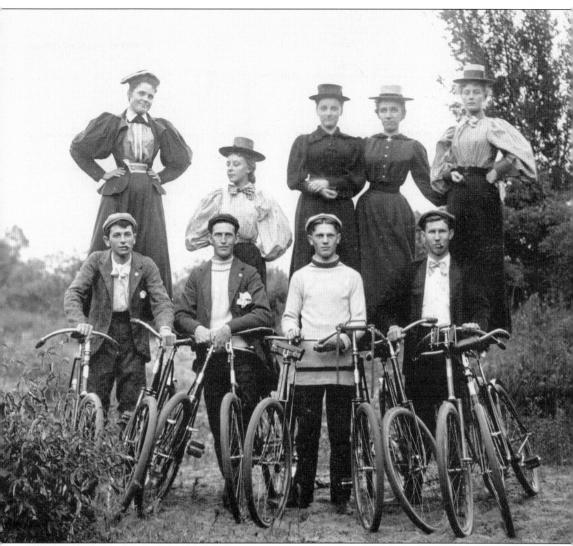

This photograph shows five young ladies with their male companions on a bicycle excursion in the mid-1890s. The female subjects are artfully posed standing on the seats of the bicycles held steady by the young men. Grand Island optometrist Max J. Egge is the man at the far right in the first row. The ladies are, from left to right, unidentified, Mette Schorupp, Edna Williams, Lulu Hetzel, and Olga Schorupp.

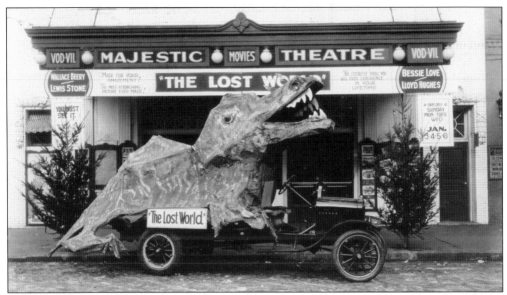

In 1925, Grand Island's Majestic Theater showed the first motion picture adaptation of Arthur Conan Doyle's novel *The Lost World*. Seen here is the theater's prehistoric creation parked outside the theater's main entrance. The creature was driven throughout Grand Island to promote the movie.

In August 1896, Grand Island's Liederkranz hosted the Nebraska Saengerbund's Saengerfest. *Saengerbund* is German for men's singing club and Saengerfest is a festival of male choruses. In honor of the festival, this temporary facade was built around the original Liederkranz building. It is believed that architect Julius Fuehrmann designed the false front as a replica of the singing society's clubhouse in Germany.

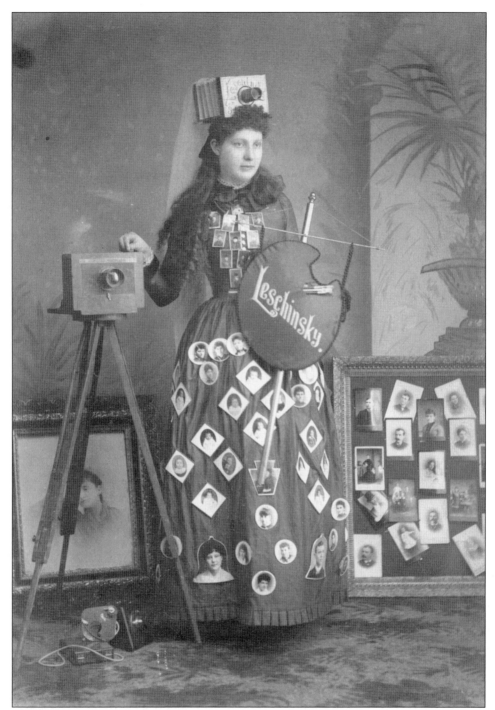

From the 1880s until his death in 1937, Grand Island photographer Julius Leschinsky used his camera to capture the people, places, and events of Grand Island history. An immigrant from West Prussia, he joined his half-brother Max Leschinsky in his new photography studio in Grand Island in 1886. The unidentified woman featured in this photograph is a walking advertisement for Julius and Max's original studio that operated from 1886 to 1891.

ACROSS AMERICA, PEOPLE ARE DISCOVERING SOMETHING WONDERFUL. *THEIR HERITAGE.*

Arcadia Publishing is the leading local history publisher in the United States. With more than 3,000 titles in print and hundreds of new titles released every year, Arcadia has extensive specialized experience chronicling the history of communities and celebrating America's hidden stories, bringing to life the people, places, and events from the past. To discover the history of other communities across the nation, please visit:

www.arcadiapublishing.com

Customized search tools allow you to find regional history books about the town where you grew up, the cities where your friends and family live, the town where your parents met, or even that retirement spot you've been dreaming about.